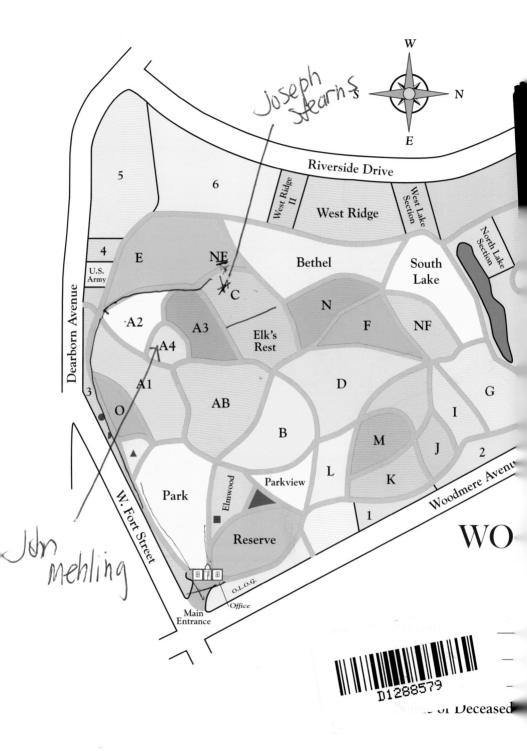

Joseph Stearns

John Mehling

W
S N
E

Riverside Drive

5 6 West Ridge II West Ridge West Lake Section North Lake Section

4 E NE Bethel South Lake

U.S. Army C

A2 A3 N NF

Elk's Rest F

A4

A1 AB D G

3 O I

B M J

L K 2

Park Parkview

Elmwood 1

Reserve Woodmere Avenue

Dearborn Avenue

W. Fort Street

O.L.O.G. Office

Main Entrance

WO

D1288579

Name of Deceased

IMAGES
of America

DETROIT'S
WOODMERE CEMETERY

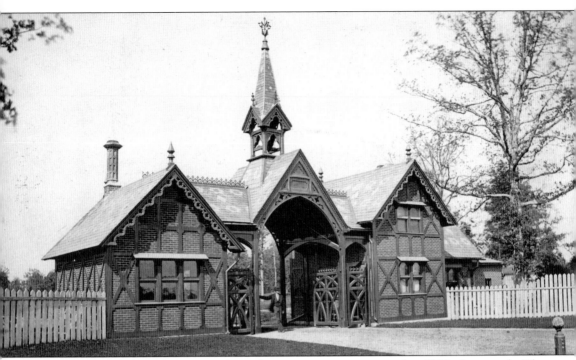

An unidentified gentleman stands in the cemetery entrance in this 1880 photograph. The 19-by-14-foot office is on the left, and the superintendent's lodge is on the right. Designed to look like the old houses in England, the first floor had a 14-by-12.5-foot living room, a kitchen measuring 12 by 10 feet, and a few smaller rooms. The second floor had two bedrooms. (Courtesy of the Burton Historical Collection, Detroit Public Library.)

On the cover: Christian Haberkorn, born in Detroit on July 27, 1856, moved to San Francisco, becoming instrumental in constructing some of the city's largest buildings. Returning to Detroit, he became a furniture manufacturer. He was treasurer of Grosse Pointe Park Corporation and president of Haberkorn Investment Company. He died on June 2, 1915, and is buried in section H. (Author's collection.)

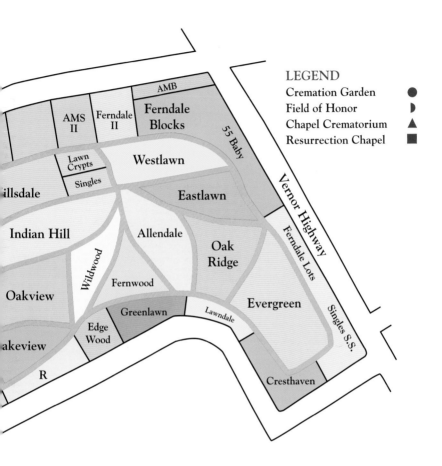

LEGEND
Cremation Garden ●
Field of Honor ❭
Chapel Crematorium ▲
Resurrection Chapel ■

AMB
AMS II
Ferndale II
Ferndale Blocks
55 Baby
Vernor Highway
Lawn Crypts
Westlawn
Singles
illsdale
Eastlawn
Ferndale Lots
Indian Hill
Allendale
Oak Ridge
Wildwood
Fernwood
Oakview
Greenlawn
Lawndale
Evergreen
Singles S.S.
akeview
Edge Wood
R
Cresthaven

DMERE CEMETERY

00 W. Fort Street • Detroit, MI 48209
one 313/841-0188 • Fax 313/841-4160

*By pre-planning, you can save
up to 50% of the cost of burial.
Call for a free consultation with
a pre-need counselor.*
313/841-0188

IMAGES
of America

DETROIT'S
WOODMERE CEMETERY

Gail D. Hershenzon

ARCADIA
PUBLISHING

Copyright © 2006 by Gail D. Hershenzon
ISBN 978-0-7385-4120-4

Published by Arcadia Publishing
Charleston SC, Chicago IL, Portsmouth NH, San Francisco CA

Printed in the United States of America

Library of Congress Catalog Card Number: 2006930980

For all general information contact Arcadia Publishing at:
Telephone 843-853-2070
Fax 843-853-0044
E-mail sales@arcadiapublishing.com
For customer service and orders:
Toll-Free 1-888-313-2665

Visit us on the Internet at www.arcadiapublishing.com

*I was a child when my grandmother, Helen Zimmer, and my great-aunt,
Laura Yob, introduced me to Woodmere Cemetery.
This is dedicated to their loving memory.*

CONTENTS

ACKNOWLEDGMENTS

My life has been blessed with great family and friends. To May Brasch, Vera and Michael Kolotila, Norma Rechlin, the Tom Palkoski family, the Johnny Wolf family, and the Norman Wolf family, thank you for your loving support, which has made all the difference. To Tom and Valerie Koselka, thanks for your research and constant interest in the book. Kudos to Garie Thomas-Bass, whose love for the world should be a model for everyone and who has cheered me on when I needed it the most.

This book could not have been written unless people were willing to share their stories. Many thanks to those who took the time to jot notes, write paragraphs, or tell me their stories personally so others could enjoy them.

In doing this project, I met people who extended themselves so graciously. Elaine Damron assisted me with records at Girrbach-Krasun Funeral Home. Dr. Marilyn Belamaric was so kind to allow me to photograph James Vernor's homestead. The Matheses spent an afternoon giving me historical background about Woodmere Cemetery. Bertha Miga, Dearborn Historical Museum research assistant, withstood the heat in an un-air-conditioned room searching files and making copies. Clare Koester, a volunteer at the Grosse Ile Historical Society, cheerfully assisted me with information in their archives.

Our libraries are staffed with very dedicated people. To Kris Rzepczynski at the Library of Michigan, Mark Bowden, Mark Patrick, Rime Minor, and Ashley Koebel at the Burton Historical Collection, and Bacon Memorial Library's Beth Kowaleski, heartfelt thanks for your assistance.

I am grateful for Rovenie Crutcher, Ray Dockham, Mary Fenech, Trina Floyd, Henry Griffor, Carlos Martinez, John Minor, Brian Morgan, Bill Shaw, Michael Sherlock, James Sizemore, Mike Vail, Maxine Vargo, Nellie Velazquez, and Eric Wolff at Woodmere Cemetery for their tireless answers to my hundreds of questions. Many thanks to you all.

INTRODUCTION

In Detroit on July 8, 1867, mothers were grocery shopping at Farquahar and Company. Children enjoyed an ice-cold soda at the Polar Soda Fountain inside People's Drug Store. Men gathered at William Duncan and Company to select new bridles. Families were holding their breath as Annie Worland walked a single wire from the ground to the top of the pavilion at the George W. DeHaven Imperial Circus that was in town. Couples boarded the *Morning Star* side-wheel steamer at the Michigan Central Railroad Wharf to travel to Cleveland.

Some were discussing the tragedy of a boy who, on the Fourth of July, was driving home a cow when he was hit by a pistol ball, inflicting a fatal wound. It was thought that this deathblow came from a careless child who celebrated the holiday with a firearm. More shootings may have occurred, as on previous Fourths, but rain brought the holiday celebration to an early close. Many were still mourning the loss of their country's beloved president, and of their sons, brothers, fathers, and husbands killed in the Civil War that ended only two years earlier.

But in the office of Charles Walker, a prominent attorney, 30 men, including John Bagley and Daniel Scotten, discussed Detroit's need for a rural cemetery. Forming an organization purchasing about 250 acres of land, they issued $50,000 worth of stock. Each anted up $500 to $5,000 for a piece of Woodmere Cemetery.

Detroit's Woodmere Cemetery, the largest and oldest of three Michigan cemeteries named Woodmere, is located at West Fort and Woodmere Streets. It sits on about 250 acres of dry and sandy, hilly land dotted with various trees including chestnut and maple. In the early years, it was so heavily wooded that the cemetery office's fireplace always had firewood. It is home for squirrels and foxes. Woodmere Lake provides a habitat for aquatic wildlife that offers tranquility only being outdone by the twittering of chickadees and cardinals.

The land, containing an area of white sand, originally belonged to the Native Americans. Later French settlers occupied it. Beds of ferns and blue-fringed gentian lined its Baby (pronounced "Baubee") Creek. It was covered with lily pads that crept from the lily and Egyptian lotus–filled Rouge River. The ditches along Fort Street "seemed to run with blood" when it rained, caused by the remains of pyrites containing sulphur and iron.

The new cemetery would be away from the city's busyness and would be larger than Elmwood. There were many little burial grounds and City Cemetery (also known as Russell Street Cemetery) that had fallen to decay. City Cemetery, opened in the 1830s, became an eyesore. Detroiters were outraged at this ramshackle site with busted headstones and rambling weeds. Other cemeteries simply disappeared, causing Clarence Burton to lament to the *Detroit News Tribune* in 1899 that "the center of town is composed in part of the dust of the forefathers of the village of ancient

Detroit." The *Detroit Free Press* reported in 1877 that City Cemetery's plat had vanished. After City Cemetery closed and the bodies were removed, excavation in that area later on found even more skeletons. Throughout Detroit, as more building was being done, more human remains were found. When one particular burial site was removed, a smallpox epidemic broke out so the digging ended. The Woodmere group felt, for sanitation reasons, a cemetery should not be near a dense population. Springwells Township, just over a mile from the city limits, was close enough for Detroit residents, who numbered about 80,000, to bury their loved ones.

Changes in cemetery layout were occurring in cemeteries across the nation. Taking on characteristics of a park started with Adolph Strauch, who helped plan Cincinnati's Spring Grove Cemetery, the model for all new cemeteries.

Many cemeteries were visited, including Spring Grove, to plan Woodmere. They purchased land, known as the Old Shipyard tract, for about $125 per acre. In 1895, the *Encyclopedia Americana* named Woodmere as one of the 39 principal cemeteries in the country whose reputation was based on beauty, size, and professional management.

The association elected a board of directors and created bylaws. They voted five to four, making Woodmere Cemetery the official name. They hired a landscape gardener, a surveyor, and a superintendent. Fencing was bought and installed, and a topographical map was submitted for approval. Adolph Strauch was paid $100 for his cemetery design, and in 1868, construction began.

In November of that year, Anna Maria Schwartz became the first person buried at the cemetery in section C. Removals from City Cemetery were reburied at Woodmere, and they received some of the 4,000 bodies, including one woman who was thought to have been buried alive during the cholera epidemic in 1833. Valentine Geist, the city sexton, was paid $2,337 for removing the bodies, but more were found when a street near the old cemetery was widened.

On February 22, 1869, a stockholders meeting was held, not as an association but as a corporation. The seventh article of this new corporation stated that "said corporation shall continue thirty years from the day of the date of these articles." Finally they planned a grand opening celebration and opened the gates to the public. Invitations were sent to the mayor, the common council, clergymen, and the press. Notice of opening day was passed on through the newspapers. At 4:00 p.m. on July 14, 1869, the gates were thrown open for the dedication. Streetcars ended about two miles from the entrance, so many people walked the distance from the streetcar and then another half mile where the ceremony was held in the cemetery. They had just experienced a heavy thundershower so finding paths clear of mud was almost impossible. But still, the well dressed came with the desire to see this wooded land transformed. Ellery Garfield, chief marshall, directed the procession that was led by music provided by the Bendix's Opera House Band. Next came the cemetery's president, John J. Bagley. Mayor William Wheaton, city officers, common council members, clergy, and Charles Walker followed. Those coming on foot followed those who came in carriages. The ceremonial stand, decorated with evergreens, was set up on one of the highest elevations in the cemetery. Music was provided by Professor Bendix' s orchestra followed by prayer by Rev. T. C. Pitkin from St. Paul's Church. The band played preceding a scripture reading from Genesis 23 and Psalm 39 by Rev. F. A. Blades from the Detroit District M. E. Church. Charles Walker spoke. More music and another prayer by Rev. William Hogarth preceded Rev. George Chace's benediction. The ceremony lasted less than an hour.

Over the years, more land was bought and some of it sold. The board of directors changed with some positions being passed down to descendants.

Detroit's Woodmere Cemetery tells about those having no money to buy a grave to those whose monuments seem to disappear into the tallest trees. It is about those who built empires, those who lost fortunes, and those who fought for their country. It is about next-door neighbors, those who contributed significantly to the lives in their own circle of family and friends. It is about people who shaped Detroit and its suburbs.

One

CONCEPTION AND DEVELOPMENT

Now officially in business, there were still decisions to make and much work to do. More land was purchased to increase the size of Woodmere. The undeveloped areas were slowly being platted and landscaped. Fort Street would continue to be a problem. Funeral processions were getting stuck in its mud, forcing some to take an alternate and longer route to reach the cemetery. Streetcar lines were extended, and at one time, a streetcar entered the cemetery and circled the entrance picking up and dropping off visitors. Buildings were erected with some being demolished and some stricken by fire. Woodmere would survive changes in ownership, union strikes, and competition with new cemeteries opening in and around Detroit.

Cremation was introduced to Detroit with the arrival of Dr. Hugo Erichsen establishing the first crematorium in Michigan. His mother, living in Pennsylvania, was incinerated, as it was called at the time, in 1885. He came to Detroit, placing advertisements in the newspapers, inviting anyone interested in the process to come to a meeting held on August 7, 1885. That night the Michigan Cremation Association was born. They wanted to build the crematorium at Woodmere, but the trustees said no. Another spot was chosen on Marston Court near Woodward Avenue, but the neighborhood strongly objected. They purchased land near Koch and Oakland Avenues, keeping the transaction quiet so the neighborhood would not know about it until the matter was completed. There was still flak, so the land was returned to the owner, fearing a lawsuit if they continued with their plan. Purchasing a lot on the corner of Fulton and Govin Streets, the crematorium was built in 1887. Within a few years, 11 crematoriums throughout the country were established, including one at Woodmere.

In January 1899, a new corporation was formed with the first one expiring on February 22, 1899. Everything transferred from Woodmere Cemetery Corporation to Woodmere Cemetery Association. Burial sections now number over 50. Digging graves by hand has been replaced by a backhoe. Descendants of the original stockholders eventually were no longer interested in running a cemetery, so it was sold. It has had several owners and is now owned by Mikocem, Incorporated.

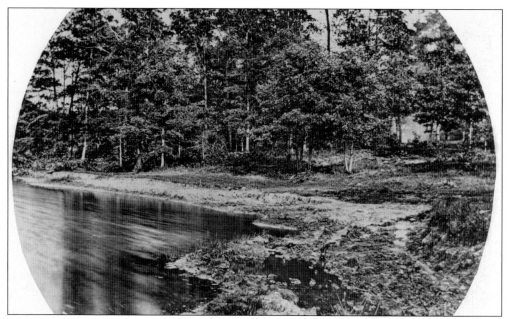

Native Americans once populated the land purchased for this new burial ground. Many of the roads constructed throughout Woodmere Cemetery follow paths they used for hunting and camping. The plan was to have the two creeks that divided Woodmere dredged and cleared, forming lakes that would extend over two miles. (Courtesy of the Burton Historical Collection, Detroit Public Library.)

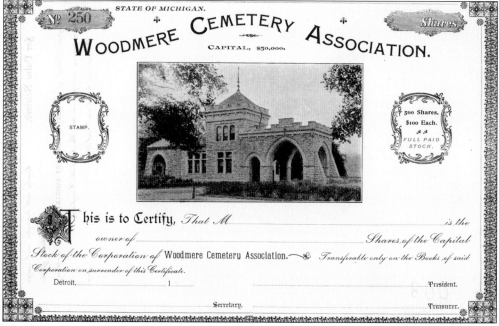

Those wanting ownership in the new cemetery received certificates showing the number of shares they held. Moses Field, Lemuel Davis, and Eber Ward each put in $5,000, the most invested by any of the original stockholders in 1867. Dividends as high as 12 percent were paid to stockholders. (Courtesy of Woodmere Cemetery.)

10

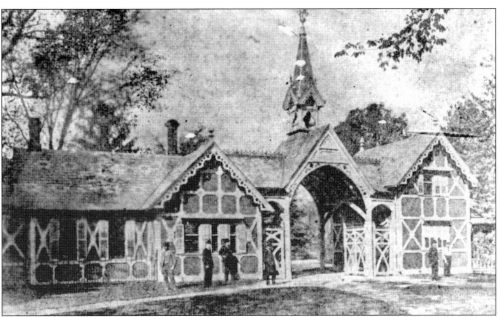

This photograph of the cemetery's entrance was taken after 1887, when the board of directors approved an addition built onto the office. This was the first structure housing the superintendent's quarters and the office. Having no chapel at this time, the office was used by those wishing a funeral service held on the cemetery grounds. (Courtesy of the Burton Historical Collection, Detroit Public Library.)

RULES AND REGULATIONS

OF

WOODMERE CEMETERY ASSOCIATION;

WITH HISTORICAL SKETCH, ETC.

DETROIT, MICHIGAN, 1895.

A rules and regulations booklet was distributed to plot owners reminding them of such things as, "Horses must not be left without a driver unless securely fastened, *and must not be hitched to trees,*" and, "No children will be admitted unless attended by some person who will be responsible for their conduct." (Courtesy of Woodmere Cemetery.)

WOODMERE
CEMETERY
DETROIT

Everything was being done to make Woodmere Cemetery the best cemetery in the world. The board of directors issued this booklet, giving the background of the cemetery and displaying beautiful photographs and drawings to first-time visitors, selling them on Woodmere's beauty and international reputation. Rules and regulations booklets were given to new plot owners covering everything from which kinds of monuments could be erected to the kind of conduct that was expected when visiting the cemetery. The owners took advantage of the law that took effect on February 19, 1869, stating saloons were to be kept at a distance of quarter of a mile from the entrance of a cemetery. There had been at least one violation of this law near Woodmere's entrance, and Charles Walker took the matter into his own hands, resolving the problem. (Courtesy of Woodmere Cemetery.)

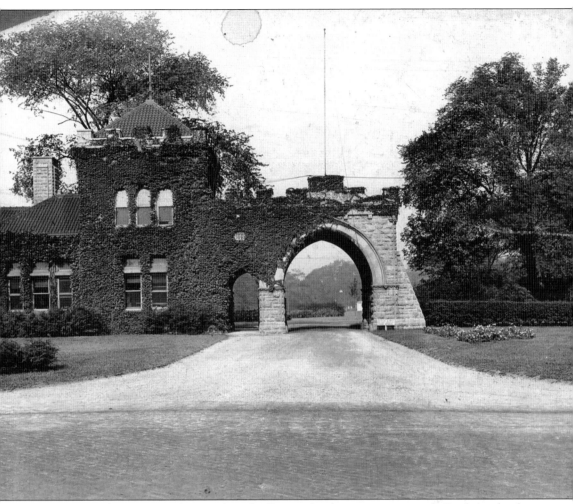

In April 1915, $300 was used to purchase birdhouses for the cemetery grounds. Looking closely through the archway to the right, a birdhouse can be seen on top of a pole. The sign on the right side of the archway reminds visitors that the speed limit is 10 miles per hour for all vehicles. Peeking through the ivy above the pedestrian entrance, the date of the original building, 1869, and the date for this present building, 1897, can be seen. The office to the left of the archway still exists, but the archway was removed when trucks could no longer fit through. Most of the landscaping seen here was done by superintendent Fred Higgins. Up until his death in 1910, Higgins was the one who selected all plants to be used for Woodmere's beautification. His handiwork won acclaim from other cemetery superintendents. At one time, streetcar tracks extended through the cemetery's entrance, a major accomplishment by Higgins. (Courtesy of Woodmere Cemetery.)

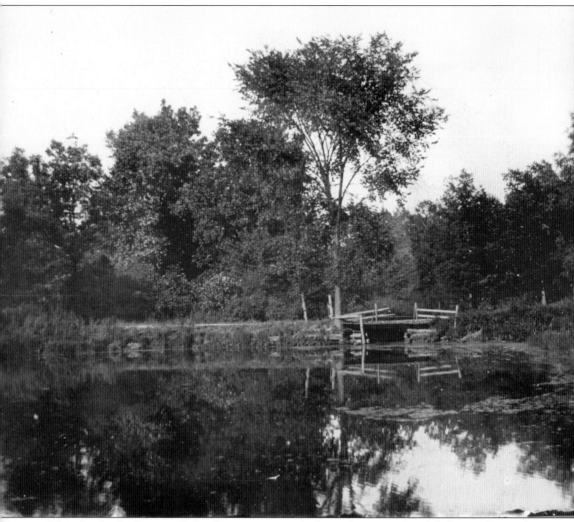

This wooden bridge provided a place to pause and admire the water. Careful planning was taken when the cemetery was designed. When this part was readied for burials, the oak trees were the first to be removed due to their intolerable appearance. Other decorative trees whose leaves did not stain the monuments or kill the grass would replace them. The creeks were laden with spectacular lilies, and it was thought that area florists gathered the lilies to be sold in their shops. Before the water was dredged, artists would come to sketch the roaming animals and wildflowers. John Owen, a landscape artist, was known for his autumn scenes he painted of this area. He was disappointed when the dredging was done, causing the area to lose one of its most picturesque spots. (Courtesy of the Burton Historical Collection, Detroit Public Library.)

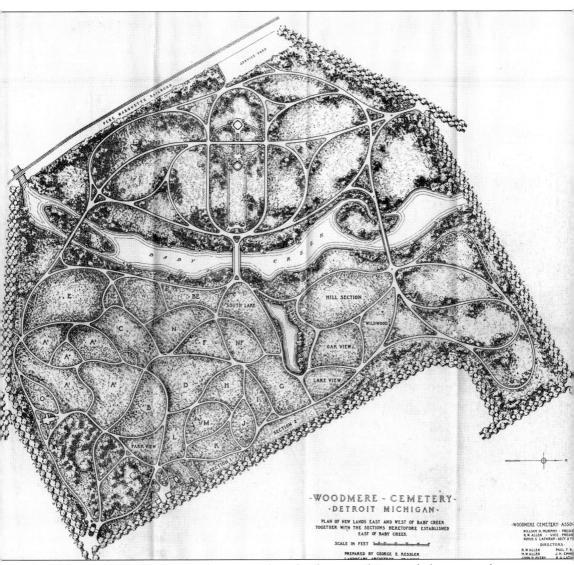

- WOODMERE - CEMETERY -
- DETROIT MICHIGAN -

PLAN OF NEW LANDS EAST AND WEST OF BABY CREEK
TOGETHER WITH THE SECTIONS HERETOFORE ESTABLISHED
EAST OF BABY CREEK

SCALE IN FEET

PREPARED BY GEORGE E. KESSLER
LANDSCAPE ARCHITECT

-WOODMERE CEMETERY- ASSO
WILLIAM H. MURPHY - PRESI
R. W. ALLEN - VICE - PRESI
RUFUS G. LATHROP- SEC'Y & TR

- DIRECTORS -
R. W. ALLEN PAUL F. B
M. W. ALLEN J. H. EMM
JOHN H. AVERY R. G. LATH

In 1913, George Kessler was hired as a consulting landscape architect to help prepare the new addition to the cemetery. He was paid $3,000, with this drawing being one of his projects completed in 1916, showing the land west of Baby Creek that had been acquired. The cemetery still had land east of Baby Creek that was not developed, which would later become sections Cresthaven, Evergreen, West Lawn, East Lawn, Lawndale, Greenlawn, Fernwood, Allendale, and Ferndale. Plans to increase the size of the cemetery fizzled, and in October 1919, the corporation sold about 90 acres west of Baby Creek to Dix-Ferndale Land Company. The plans had been well publicized, and many maps were printed up to be distributed to potential cemetery lot owners. The cemetery would remain the size east of Baby Creek. In 1967, Baby Creek was filled in. (Courtesy of Woodmere Cemetery.)

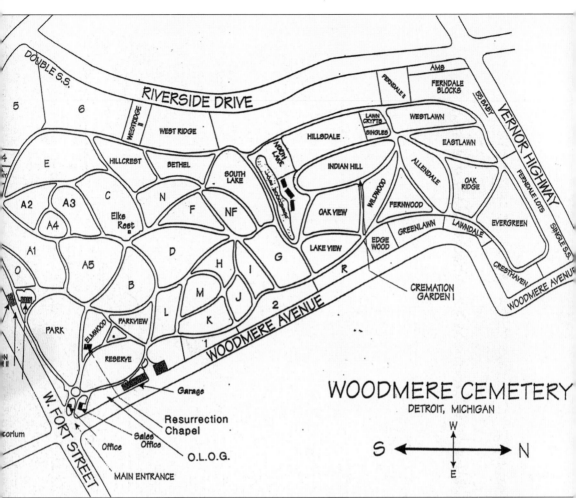

This is the cemetery as it looks today. What was once Deer Creek is now Lake Woodmere. Baby Creek used to run where Riverside Drive and the sections directly next to it are now. Sections number over 50, with a few more in the plans. There is still some undeveloped land that eventually will be platted to accommodate more burials. Gone are the turnstiles at the corner entrances. No longer is the cemetery patrolled by a uniformed patrolman as it had been in its early years. Missing are the wagons, horses, bicycles, and trucks, which were the earlier means of transportation within the cemetery. West Fort Street, once the subject of contention, is now a paved road, as are the roads within the cemetery. (Courtesy of Woodmere Cemetery.)

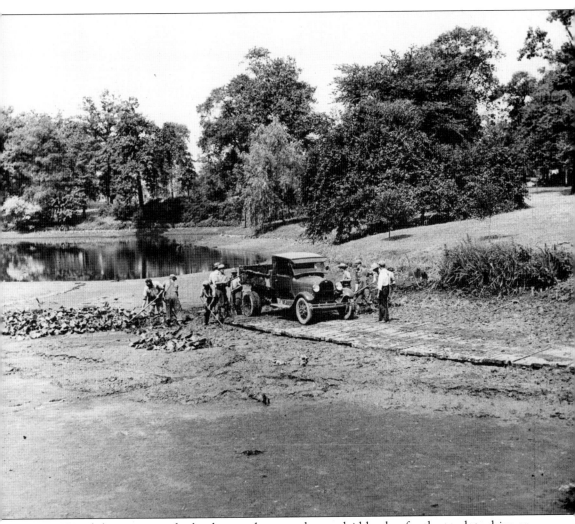

In 1931, while improving the landscape, the grounds crew laid lumber for the truck to drive on, saving it from getting stuck in the mud. The cemetery had purchased several vehicles over the years, including a $1,500 Packard and two bicycles for the foreman to use in 1911. In 1904, when horses and carriages were still the fashion, a wagon had been bought to transfer bodies from the streetcar funeral car to the cemetery. Constantly improving for utility as well as appearance, a turnstile once stood at the gateway on the corner of West Fort Street and Dearborn Road. A cement walk was installed along West Fort Street in 1902. In 1909, the superintendent could be contacted via the newly installed telephone by calling Cedar 1806, and there always seemed to be the need for new fencing, whether cedar, wire, or cast iron. (Courtesy of Woodmere Cemetery.)

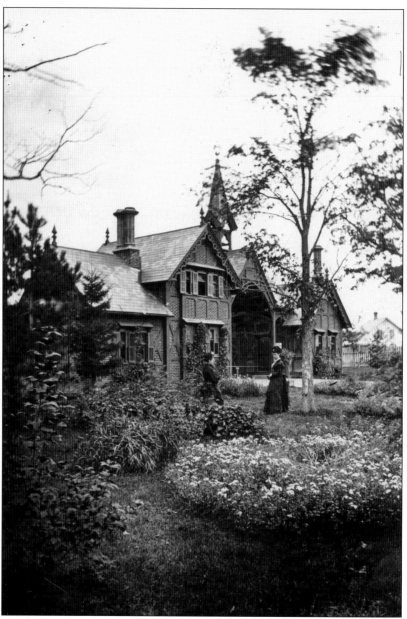

This photograph dated 1880 shows two unidentified ladies standing inside the cemetery, facing the back of the superintendent's quarters on the left and the office on the right. The gardens were the responsibility of Fred Higgins, whose sterling reputation for landscaping was known throughout the United States. Well-known for the transformation of Woodmere Cemetery, he met with horticulturists who made deliberate trips to the cemetery to examine a new variety of tree or plant. He cultivated the Pepperidge trees that grew in abundance there but were rare in other parts of the city. Tulip, catalpa, and maple varieties flourished under his care. Wanting to maintain an attractive cemetery, he also gave plot owners Latin names of various flowers they could plant. He stressed flowers should vary among the family plots, avoiding duplication that would bring monotony to the cemetery. (Courtesy of the Burton Historical Collection, Detroit Public Library.)

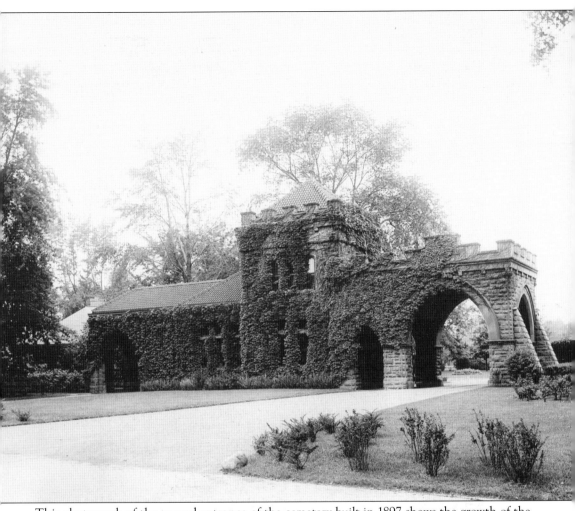

This photograph of the second entrance of the cemetery built in 1897 shows the growth of the ivy overtaking the building. Having an office with a window was probably not an issue for the office workers back then, with visibility impaired by the ivy. On the far left, part of the first waiting room can be seen. That waiting room, the arches, and the ivy were removed in later years. The fireplace inside the office was removed, with the vault taking its place. One of the first purchases the board of directors made was a safe. The safe was put in place in the office and then a wall was constructed to enclose it, creating the vault. Even though the safe was put on casters for mobility, it cannot be removed since it cannot fit through the vault door and is no longer used. (Courtesy of Woodmere Cemetery.)

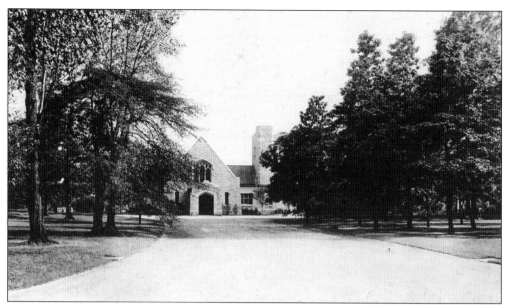

In 1911, Donaldson and Meier, doing extensive research into famous chapels, designed Woodmere's Gothic-style chapel. The architects were used by the Detroit Boat Club to build a clubhouse in 1891, and they designed St. Hyacinth Catholic Church, University of Michigan's Alumni Memorial Hall and dental building, and Ann Arbor's Grace Bible Church. Starting with the existing receiving vault, they designed the chapel and crematorium around it. (Courtesy of Woodmere Cemetery.)

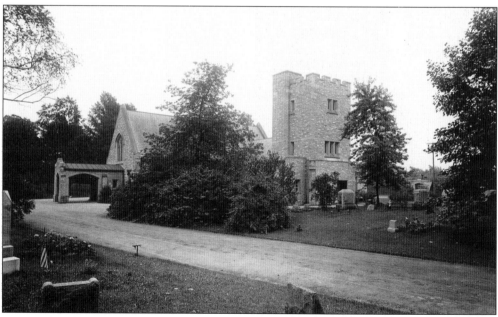

Not much is known about A. Kay Herbert, but he designed the stained-glass window, dated 1930, that graces the chapel's entry. A few of his other works can be seen at Trinity United Methodist Church in Grand Rapids, and Holy Redeemer Church and Little Rock Missionary Baptist Church in Detroit. (Courtesy of Woodmere Cemetery.)

Inside the chapel sets a pump organ, style 86J, the workmanship of Mason and Hamlin in Boston, Massachusetts. The pipes are a facade. It used to set in the choir loft, but is no longer used. The organ was a gift from Mrs. Louis Pfeiffer and her daughter, given in memory of Conrad Pfeiffer.

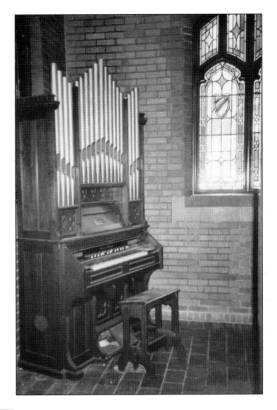

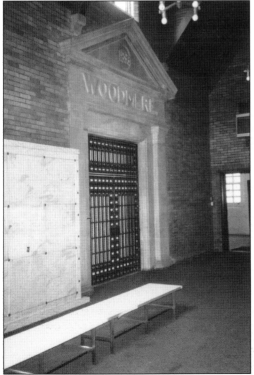

If a funeral was delayed until out-of-town family arrived or because of inclement weather, the receiving vault held the deceased until burial took place. If a mausoleum were being built, the body was placed in the vault until the construction was completed. Those who died of infectious or contagious diseases were not permitted in the vault. If the remains became offensive or detrimental to the public's health, the cemetery retained the right to bury the body. The vault could hold 80 bodies.

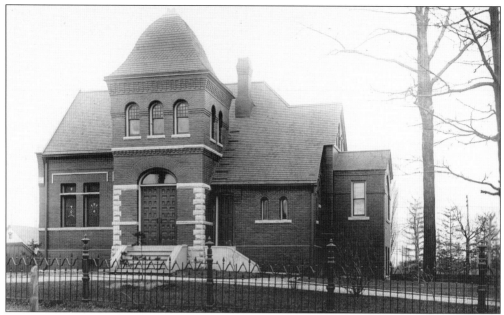

In 1929, the Detroit Crematorium and Columbarium closed its doors. The Cremation Association had accomplished its goal and no longer wanted to maintain an independent organization. Woodmere started its cremation services on April 11, 1913, so the Detroit Crematorium and Columbarium's ashes and niches were brought to Woodmere. The building no longer exists, and Woodmere ceased operating its crematorium on January 22, 1999. (Courtesy of the Burton Historical Collection, Detroit Public Library.)

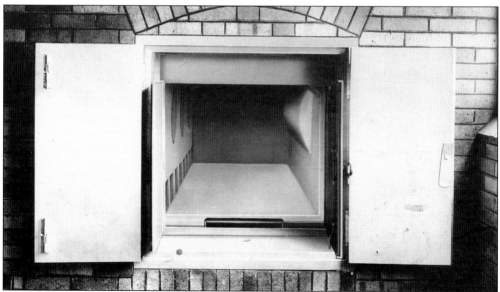

The crematorium has two retorts. About 90 minutes was required to complete the process. A room adjacent to it, now the columbarium, was reserved for loved ones to wait while a cremation took place. A portrait of Barbara Schorr, the first person to be cremated in Michigan and the Northwest, hangs near the crematorium. Her cremation took place on December 10, 1887, at the Detroit Crematorium and Columbarium. (Courtesy of Woodmere Cemetery.)

NOTICE

Detroit, Mich., October 1, 1929.

Dear Madam/Sir:

On the 30th of April, 1929, the Detroit Crematorium closed its doors forever, after transferring its business and good-will to the Woodmere Cemetery Association. The crematorium of the latter will henceforth be known as the Woodmere-Detroit Crematorium, thus combining the two names. At the same time the Woodmere Cemetery Corporation assumed our obligations towards our niche-owners which are defined in the certificate of title we issued to you at the time of your purchase of Niche No.

_____ in Section _____ of the Detroit Columbarium, as our columbarium was hitherto called. As you will note you have ninety days from the date of this notice to select a new niche and if you do not make a selection by the end of that time the cemetery authorities will be authorized to make the selection for you.

The transfer of ashes from the old columbarium to the new was accomplished Wednesday, Sept. 25th, 1929, in the presence of the undersigned and Superintendent Ludwig Pfaller of Woodmere Cemetery. The new columbarium of the Woodmere-Detroit Crematorium is constructed of white marble and compared to the old is a thing of beauty. It will surely please you. When you call at the Woodmere Cemetery office, 9400 West Fort Street, please bring this notice and your certificate of title with you.

In the opinion of the undersigned in order to properly preserve the equities of all the parties to this transaction, it will be necessary for the Woodmere Cemetery Corporation to issue new certificates of title defining the location of the new niche according to section and number. In that instance, of course, your old certificate of title will have to be surrendered.

The secretary has made use of the last addresses given him by the niche-owners. If this notice should therefore fail to reach you on account of a change of address, it will manifestly not be his fault.

Kindly attend to this matter of niche selection, as promptly as possible, and oblige.

Yours very respectfully,

HUGO ERICHSEN, M. D.
Secretary, Michigan Cremation Association.

Dr. Erichsen sent this form letter to each niche owner announcing the closing of the Detroit Crematorium and Columbarium. The columbarium had been located a short distance from Woodmere, but the structure is no longer in existence. (Courtesy of Woodmere Cemetery.)

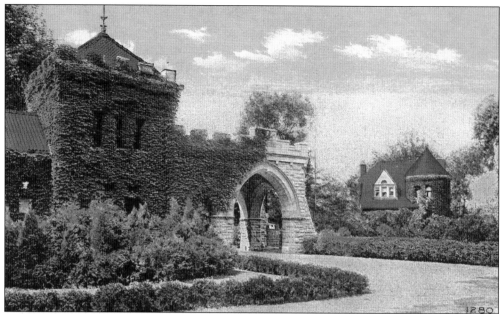

A fire broke out in the superintendent's home on April 3, 1897. After Fred Higgins kindled the kitchen stove, he left the room. A fire started between the ceiling and the roof. Higgins sounded an alarm, and enough people came and removed most of his possessions. Removing an archway connecting his residence to the office prevented the fire from spreading. This postcard shows the office and superintendent's home, both replacing the original buildings.

Built in the 1930s, this is the existing home on the grounds. Over the years, it has been the home of superintendents and owners of the cemetery and was converted into office space. There was one other house for the assistant superintendent located near section R, but it no longer exists.

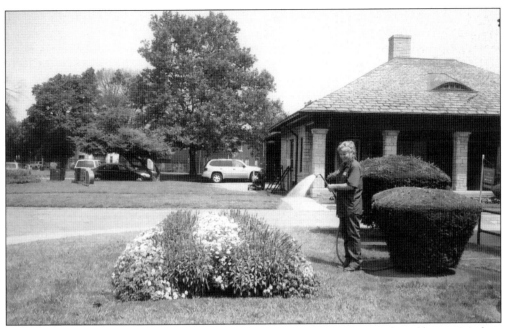

Mary Fenech grew up in the present superintendent's house when her father, Thomas Mathes, was an owner and the superintendent of Woodmere Cemetery. She moved out when she got married, but she is back this time as an employee, with tending to the flower gardens one of her many responsibilities.

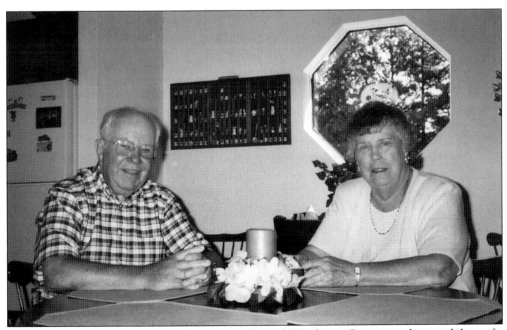

Thomas Mathes, former owner and superintendent of Woodmere Cemetery, along with his wife, Regina, and four daughters, lived in the present house from the early 1960s to the early 1990s, when he retired. Starting as an assistant superintendent, Tom's employment began with the descendants of the original owners. Regina worked in the office maintaining cemetery records.

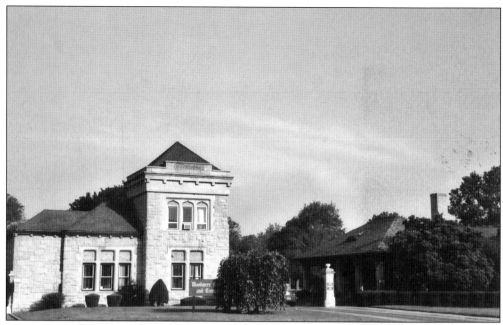

The present office is located on the left upon entering the cemetery. It had a fireplace that a 1906 newspaper reporter noted was probably the coziest place to be on a winter's day. The waiting room on the right had long benches used by visitors waiting for their rides. It is now divided into offices and restrooms.

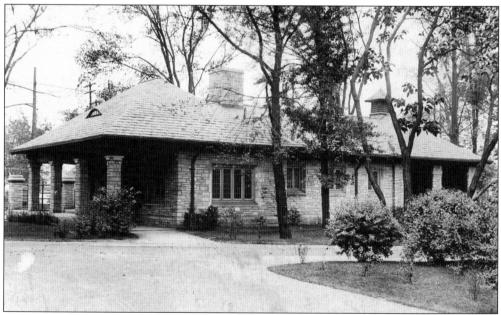

This is the waiting room that sat on the West Fort Street side of Woodmere in the early 1900s near the main office and was removed due to the widening of West Fort Street. It appears to have the same design and materials used by the present waiting room that now contains lavatories and offices. A pedestrian turnstile can be seen through the two columns at the far left. (Courtesy of Woodmere Cemetery.)

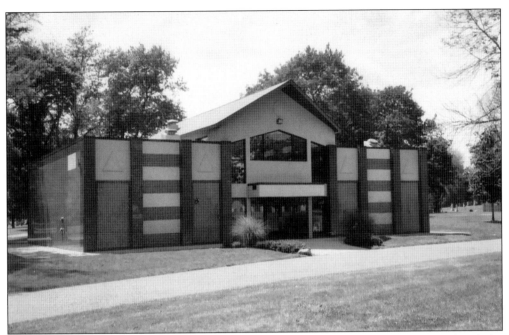

Resurrection Chapel was built in the 1990s, providing niches inside and outside of the building. This structure that can be seen upon entering the cemetery offers the perfect spot for those who prefer aboveground burial. Aboveground burial is also located on the banks of Lake Woodmere.

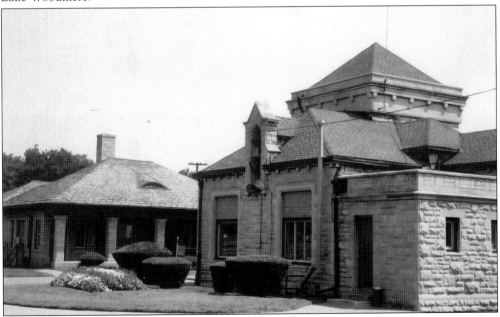

The back of the entrance shows the waiting room and office. The bell located above the office wall signaled visitors when the cemetery was closing and let the grave diggers know a funeral procession had arrived. It rang when the office staff wanted to talk to someone on the grounds. Each worker having a code would go to the nearest telephone located on the grounds when they heard their signal.

This photograph, taken in the early 1900s, shows section F on the left and section NF on the right. In its design, consideration was given as to how many and which kinds of trees should be planted. Fred Higgins was concerned with how a tree would look when grown and feared over-planting. (Courtesy of Woodmere Cemetery.)

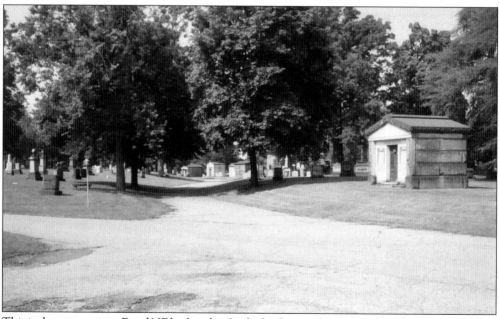

This is the way sections F and NF look today. In the background are section Beth El's mausoleums. Signposts have replaced the stones indicating the name of the sections. As of January 1, 1895, there were 20,696 interments, not including those removed to other cemeteries. Today the number is over 190,000.

Standing on section N, looking toward the Edwards' mausoleum in section F, the cemetery is crowded with trees and shrubs in this early picture. These structures were to be seen as permanent, so careful thought was given to their construction. Six-foot-deep foundations were required. (Courtesy of Woodmere Cemetery.)

Today those same sections are without many of the trees and flowering shrubs that once covered the grounds, providing more burial space. Just as shrubs or trees could not be planted or benches or urns placed without permission of the cemetery, neither could they be removed without written consent.

In this early-1900s photograph, the section on the left is now section Beth El. To the right is section N. The white monuments are easily seen through surrounding tree branches. The cemetery owners wanted to control what plot owners did to maintain the cemetery's tactfulness. Graves carelessly decorated with shrubs, trees, and flowers were seen as tasteless and defaced the beauty of the cemetery. (Courtesy of Woodmere Cemetery.)

Trees that helped protect some of the larger monuments from the elements no longer exist. Graves were given a numeral marker placed at the head of each grave. Most, although sunken over time, can still be found, assuring correct grave location for unmarked graves.

The Henkel mausoleum in section A4 used to bask in the sunlight of the cemetery. Many ornamental benches and cast-iron chairs surrounded it, and the road shows imprints from horse-drawn carriages. No burials were "permitted on Sundays, except in the case of a contagious disease, and then only in the forenoon." (Courtesy of Woodmere Cemetery.)

Today the Henkel mausoleum is constantly in the shadow of a tree planted after the mausoleum was built. Dirt roads are now replaced by pavement. It was thought that lots looked best having one large monument engraved with the surname accompanied by a low marker engraved with the deceased's first name and dates of birth and death.

Section B shows the magnitude of flowers and shrubs planted in this early picture of Woodmere. In March 1928, a local florist was caught stealing flowers off the graves. He insisted he was only taking the wire frames that held the flowers in place. The police concluded he was stealing floral pieces he had already sold in order to resell them. (Courtesy of Woodmere Cemetery.)

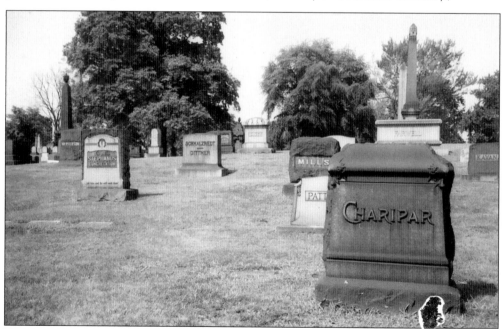

Key monuments are the only way to identify this section as being the same as in the above photograph. Trees, shrubs, and benches, too, are no longer plentiful as pictured above. Urns, once popular, are broken or gone. Monuments have darkened and headstones, once erect, lay buried in the ground.

The once-white ornate Stevens-Shipman mausoleum in section D is hidden among the trees and shrubs in this early photograph. The cemetery frowned upon any monument with filigree work, since over time it would lose its original look and tend to look gaudy. (Courtesy of Woodmere Cemetery.)

Today trees no longer obscure the mausoleum. At one time, headstones could not be taller or wider than two feet. Thickness of the stone was to be no less than 6 inches and no more than 15 inches. Plot owners were advised to pay strict attention to what kind of flowers neighboring plot owners had planted to avoid repetition.

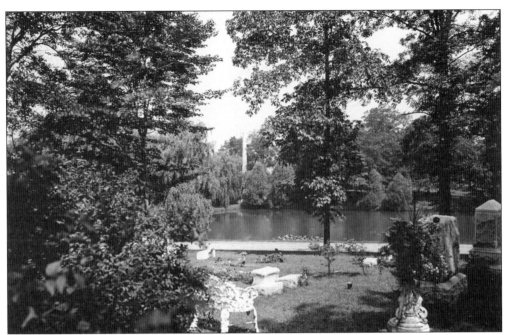

The monument of Daniel Scotten, in what was once a secluded part of the cemetery, can be seen across Lake Woodmere being viewed from section South Lake in this early photograph. Some of the lily pads that no longer beautify the lake can be seen floating in the water. (Courtesy of Woodmere Cemetery.)

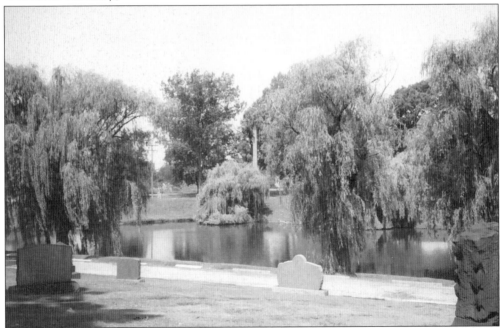

The desire for the cemetery was a neat and perfected look, with monuments that were simple and sturdy. Trees, headstones, and other ornamentation have disappeared in this photograph of today. Woodmere Lake was dredged, losing the wild lilies. The plan to have two miles of water running through the cemetery never materialized.

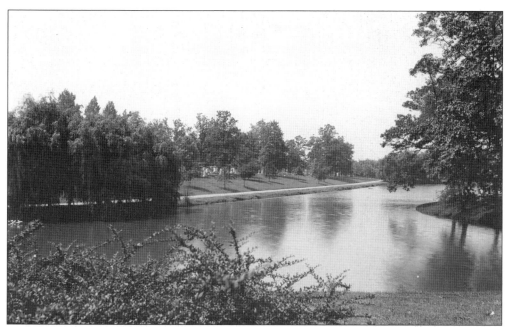

In this early photograph of Lake Woodmere, the developed side of the cemetery is on the left, with the right side needing to be cleared and platted. Creating Woodmere Cemetery, the founders wanted visitors to experience a "symbol of hope and life, not grief and death." (Courtesy of Woodmere Cemetery.)

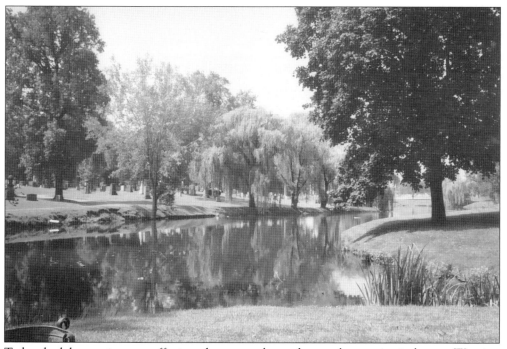

Today the lake continues to offer its calmness to those who stop by to enjoy its beauty. Weeping willow trees thrive. Including the lake in the cemetery's landscape was a deliberate move to help "exclude all that is morbid and depressing."

A well-balanced mixture of color, size, and shape of monuments was seen as being essential in keeping with the overall plan for the cemetery. The monuments were required to be constructed from cut stone, granite, or marble, as can be seen in section D. (Courtesy of Woodmere Cemetery.)

Waterlines feeding city water to the cemetery were added gradually as the cemetery was expanded. Some of the original wooden water pipes are still used. Developed since the top photograph was taken, section NF can be seen in the distance.

In this older photograph taken near the cemetery entrance is Park View (lower left), section L (upper left), the area where some of the buildings were (upper right), and the reserved area (lower right). The area in the distance was heavily wooded and was developed at a later time. (Courtesy of Woodmere Cemetery.)

Wanting to keep the cemetery rural as much as possible, even section name markers made of marble or wood were low to the ground. In later years, signposts were added, making section identification easier. Section K is seen in the upper portion of the photograph.

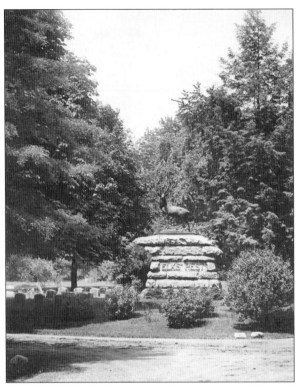

Elks' Rest sets at the edge of the oldest section in the cemetery, section C. The large monument will stand the test of time. Headstones to the left are neatly lined up under the shade in this photograph taken in the cemetery's early years. (Courtesy of Woodmere Cemetery.)

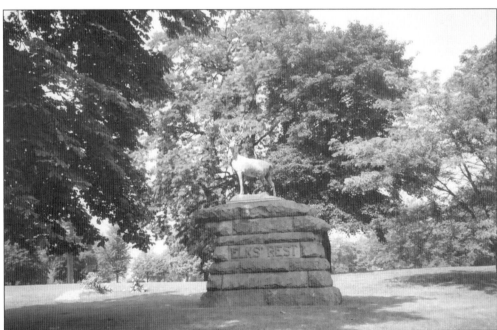

Today the headstones to the left of the monument are still there but are lying down, although the large monument has maintained its beauty. Section C was the first section platted where most of the remains from City Cemetery were reburied. After the section was filled, Woodmere ended its contract with the city to bury the city's poor.

Fit for picnic tables, this part of Woodmere Cemetery could easily be mistaken for a recreational area. With some trees spared to enhance the cemetery's rural look and ready to be platted, this section would become North Lake. The land had been purchased from the state since the owner of the land died leaving no heirs. (Courtesy of Woodmere Cemetery.)

At one time, there were over 140 varieties of trees on the cemetery grounds. Some of the trees harvested were used to make wooden coffins in the carpenter shop, which no longer exists. (Courtesy of Woodmere Cemetery.)

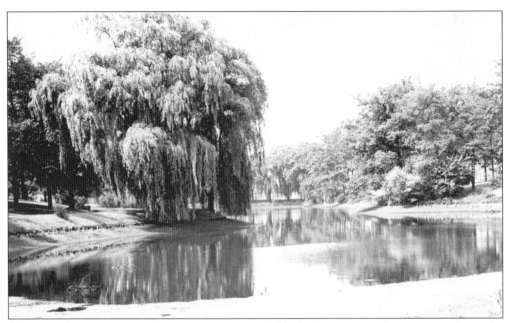

Changing the waterways in the cemetery was probably the biggest transformation in the entire cemetery. Originally wanting to capitalize on the creeks' exquisiteness, the plan was to enhance the landscape utilizing the creeks and the wildlife they contained, giving no thought that future owners of the cemetery would ever want to change it. They were wrong. In the summer of 1931, more dredging took place with one of the creeks eventually filled in about 40 years later. Some of the weeping willow trees in these pictures are still part of the scenery today. (Courtesy of Woodmere Cemetery.)

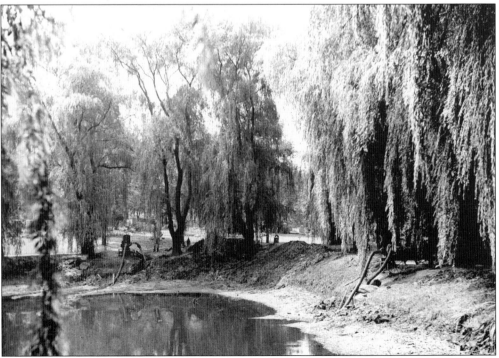

Two

PEOPLE IN THE NEWS

Detroit produced many millionaires starting in the late 1800s, predating the automobile revolution. Some came from Europe dreaming the United States would offer them something better than their motherland. Some were first-generation Americans whose childhood hardships gave them the determination to seek something better. They came to Detroit transforming ribbon farms into homes, offices, and bustling factories. The city became known for lumber manufacturing, tobacco dealings, and retail businesses. Rustic buildings were turned into elegant bank buildings and movie houses. A handful inherited their wealth and saw it grow beyond anyone's speculation. For most, they were self-made men whose hard work was reflected in their opulent homes. They not only produced personal wealth but also made a name for Detroit. Even more so, others in the community spoke highly of them. Words like integrity, character, well-mannered, and honest often appear in their obituaries and stories related by their family and friends. They carried in their hearts what would work best for the people of the city, and continually thought of others in making decisions all to the betterment of Detroit. They were a charitable bunch, often organizing new charities or contributing land, money, time, and goods to those whose lives took a different path. Supplying a mixture of faiths to the city, they were religious and were true to their beliefs. They planned, directed, served, and died, leaving a legacy for others to build on. Some people making the news were not so fortunate. For them, it was a dreadful circumstance that landed their names in the daily tabloids. Some caused their own misfortune, and some were just in the wrong place at the wrong time. All of them, the rich, the poor, the weak, the strong, those who were driven, and those who took life one day at a time, impacted Detroit and its encompassing neighborhoods as well.

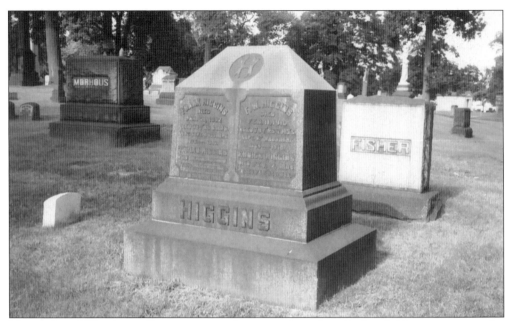

No one loved Woodmere Cemetery more than superintendent Frederick Higgins, serving the cemetery until his death on February 11, 1910. Born in New York on June 21, 1833, he came to Michigan when Woodmere was being planned. He decided everything from which trees should be planted to how the flower gardens should be designed so that continuous color would bloom throughout the spring, summer, and fall.

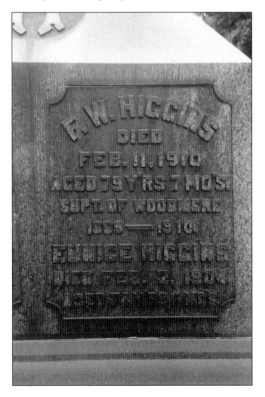

Higgins lived, died, and was buried on the cemetery grounds, with his funeral service held at his ivy-covered house. His wishes were to be placed in the receiving vault until spring when he was interred next to his wife, who died six years earlier. Vice-president of the American Cemetery Superintendents Association that he helped found, he is buried in section F.

No myrtle covers Higgins's grave, which he preferred over planting assorted flowers. In the rules and regulations booklet, Higgins stated the best cemeteries had restrictive and rigidly enforced rules. High headstones intruded on the natural beauty of the cemetery and looked like a monument maker's display. But when his son died in 1892, he understood the wanting of larger markers and erected one taller than he once allowed in section F.

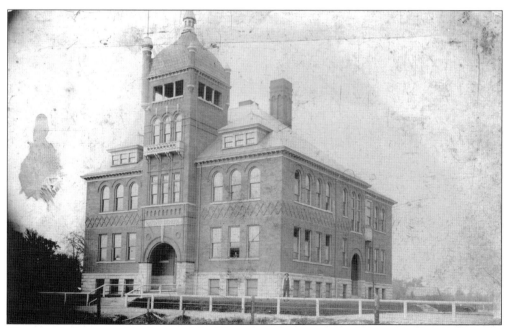

The board of directors' high regard for Higgins got him appointed superintendent for life. He was much admired and loved, and a Detroit public elementary school close to the cemetery was named for him. This original school, built in 1878, was replaced with another building in 1919. (Courtesy of the Burton Historical Collection, Detroit Public Library.)

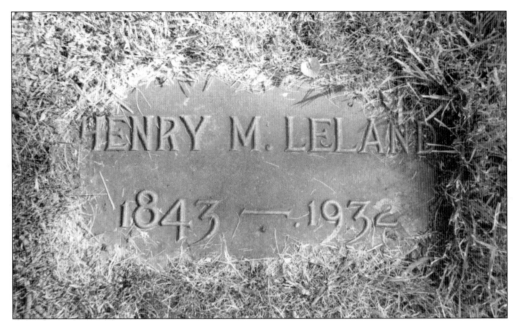

Born in Vermont and educated in Massachusetts, Henry Leland found success in Michigan. During the Civil War, he worked for Samuel Colt, making rifles for Union soldiers. Before moving to Detroit, where he established a machine shop, he invented the electric barber hair clippers. In his late 50s, he manufactured transmissions for the one-cylinder Olds automobile. After creating the Cadillac, he sold his company to General Motors. He is buried in section G.

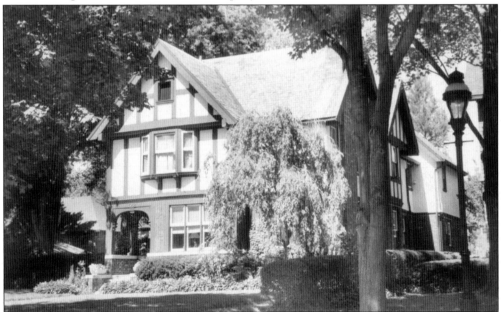

Leland formed the Lincoln Motor Company, producing Liberty aircraft engines and then luxury automobiles. Henry Ford eventually acquired the Lincoln Motor Company. Leland was hospitalized after a series of health problems. He begged to go home "just for ten minutes," and the doctors obliged. Content to have had another night's sleep in his own bed, he returned to the hospital and died on March 26, 1932, at the age of 89.

Levi Griffin, U.S. representative from 1893 to 1895, graduated from the University of Michigan. After practicing law a few years, he served in the 4th Michigan Cavalry until the Civil War ended. Practicing law again, he was unsuccessful in his bid for the state supreme court but won a seat in Congress. Becoming deaf, he left the public eye, turning to brief work to carry on his career. He is buried in section D.

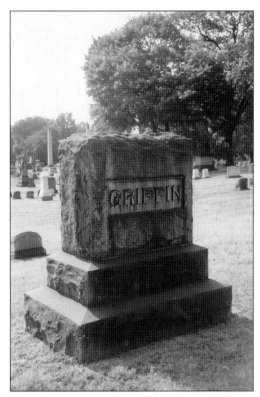

Moving to Pennsylvania, Griffin became a writer for a law publication and later moved back to Detroit before dying on March 17, 1906, at the age of 68. Notability did not come without problems. In May 1874, Catherine Murphy was given two months jail time for obtaining some meat and sugar under false pretenses. She claimed she was employed by the Griffins, which later proved to be a lie.

Born in Luxembourg in 1879, Moritz Kahn, buried in section NF, came to the United States as a child. He was a civil engineer working with such companies as the American Bridge Company and Trussed Concrete Steel Company until he teamed up with his brother, Albert, as vice-president of Albert Kahn, Inc.

Kahn died on a New York train on January 16, 1939. He was highly regarded in the construction field for his development of hollow concrete piles and steel-tile floor construction. He spent a five-month period in Russia with his company serving as the principal designers for the Soviet Union's industrial program.

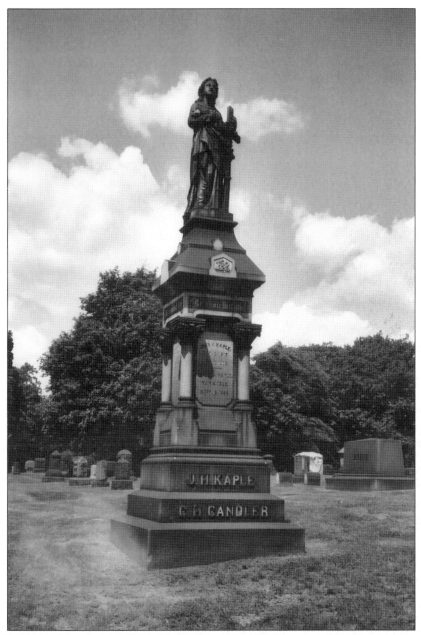

Originally from Massachusetts, John H. Kaple was involved in several business ventures in his 84 years. At his death on March 6, 1902, he was vice-president of the Michigan Savings Bank, president of the Detroit Casket Company, and a director for the Michigan Mutual Life Insurance Company. Prior to this, he had been registrar of the probate court and a postmaster. Claudius H. Candler was the son-in-law of John Kaple. A native of England, he came to the United States as a young boy. When he died on February 25, 1910, he was 64 years old and president of the Calvert Lithographing Company. He helped found the Grace Protestant Episcopal Church. Like his father-in-law, he was involved in the Detroit Casket Company as president. He also held positions with the Michigan Savings Bank and the Michigan Mutual Life Insurance Company. They are buried in section B.

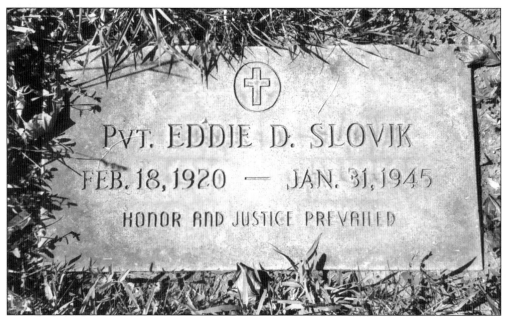

Pvt. Eddie Slovik faced a firing squad on January 31, 1945. Serving time for stealing, Slovik avoided the draft, being classified 4F. Needing more soldiers, his classification changed to 1A. Beginning basic training, he requested non-combat status but was denied. In France, he escaped twice, was caught, was court-martialed for desertion under fire, and was sentenced to death. Others deserted, too, but execution orders were only carried out on Slovik, who is buried in section Ferndale.

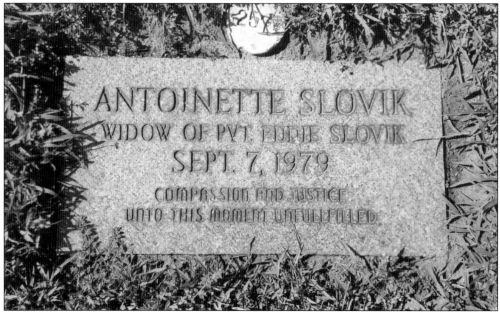

Eddie was buried in a cemetery in France. His wife, Antoinette, tried to have him pardoned and have his body returned to Michigan. She fought until her death on September 7, 1979. World War II veteran Bernard Calka took up the cause. In 1987, he succeeded in having Eddie's body returned to Michigan. On July 11, 1987, Eddie was buried next to Antoinette. Calka continues the fight to have Slovik pardoned.

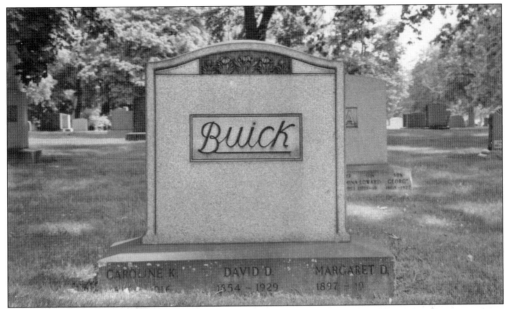

David Buick invented a bathtub enameling process before starting Buick Manufacturing Company. Overspending put him in debt. Another company, liking Buick's ideas, paid off the debt but gave Buick little control. When William Durant was hired, Buick was ignored. Buick left the company, and it later became General Motors. Buick sold some stock and went to California, buying land where oil was discovered. Who held the land title was disputed. This grave is in section Allendale.

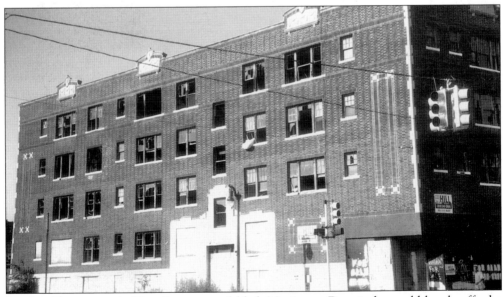

Buick sold more stock. His oil company folded. Moving to Detroit, he could barely afford a tiny flat. His last job was as a trade school instructor. He traveled by streetcar and on foot, not able to own one of his signature cars. Calling an apartment in this building home, Buick, 74, died penniless on March 5, 1929. The structure seems to parallel his life and is coming to a sorrowful end.

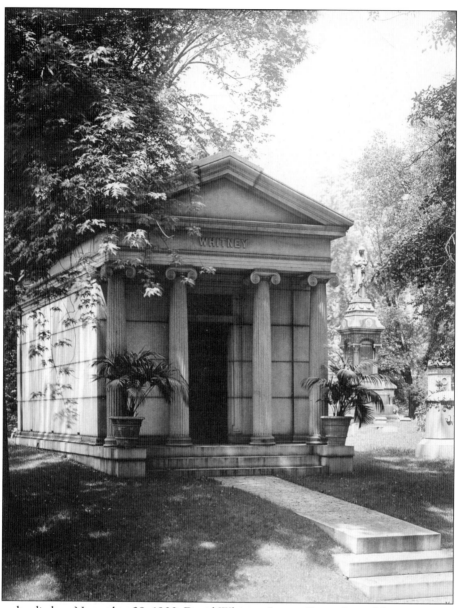

When he died on November 28, 1900, David Whitney Jr. was Detroit's wealthiest citizen, with his holdings estimated at $15 million. His father made his fortune in the farming, lumber, and brick-making businesses. David Whitney, born in 1830, started his career as a clerk in the lumber industry in Massachusetts and soon began his own business. He came to Detroit in 1857 and gained experience working for firms that bought and shipped lumber. Capitalizing on his own wisdom and his father's experience and knowledge, in 1877, he started investing in pinelands and did quite well until the lumber business began to slow down. Because of his impeccable reputation and flawless business sense, he sold the land, making a huge profit, and invested in vessel property. His real estate property included the J. L. Hudson building. His body was displayed in the drawing room of his home with its "magnificent decorations and luxurious hangings." Hundreds gathered in and around the home and lined the streets to pay their respects to this man entombed in section F. (Courtesy of Woodmere Cemetery.)

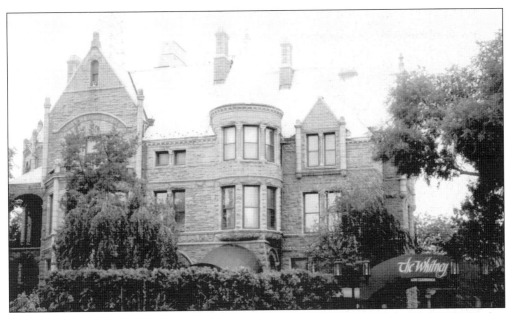

The elegant home of David Whitney Jr. is now the famed Whitney restaurant. In 1890, Gordon Lloyd designed the 42-room house with 218 Tiffany windows. This was where Whitney lived and died. J. L. Hudson, one of the pallbearers, helped carry the violet-covered casket out of the Woodward Avenue house to the horse-drawn hearse. A line of carriages waited to follow the hearse to the cemetery, to bury Whitney in section F.

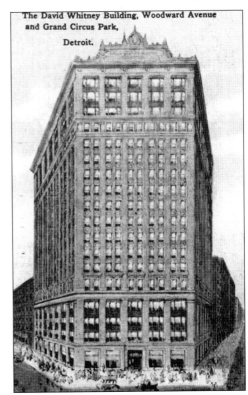

The David Whitney Building, designed by Daniel H. Burnham and Company, opened in 1915 and was named in the lumber baron's honor. Located on Woodward Avenue in Grand Circus Park, it served as offices for many businesses and housed retail stores. Whitney had been admired for his honesty and integrity.

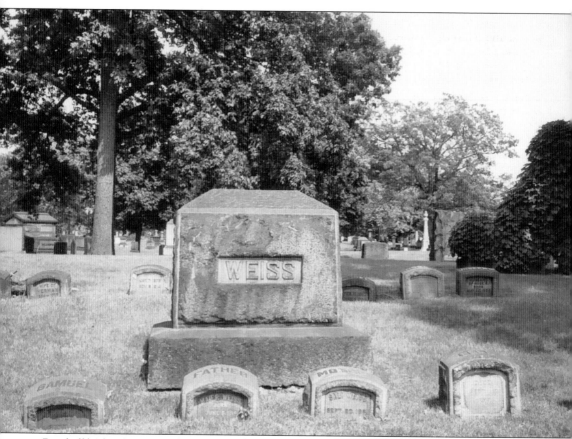

Baseball had no bigger fan than Joseph M. Weiss. In school, he formed a group that became Detroit's first professional baseball team. Touted as the Cass Base Ball Club's top pitcher, he is credited for being the first to throw a curveball. With the same zeal that brought him prominence in baseball, he became an attorney and a prosecutor of Chippewa County. In Detroit, he became circuit court commissioner, a state senator, a member of the Michigan State House of Representatives, and chaired the Michigan delegation to the National Rivers and Harbors Congress. He became president of the Detroit Amateur Baseball Association and vice-president of the Detroit Amateur Commission, formed the Michigan Naval Reserve, and was a member of the Detroit Historical Society and Gristmill Club and an honorary member of Detroit Lodge No. 34 of the Elks. He served as a director of the Detroit Base Ball Club of the National League and helped provide much-needed recreational places for Detroit's children. He died on January 11, 1937, at the age of 80. His headstone, seen in the upper right-hand corner, is located in section NF.

Dexter Ferry, from New York, worked for a book and stationery house. Having lived on a farm helped him build a successful seed company, D. M. Ferry and Company, in 1856. He was president of National Pin Company and director of Detroit Copper and Brass Rolling Mills. He chaired the Republican State Central Committee and was a member of the Board of Estimates. He died on November 11, 1907, and is buried in section F.

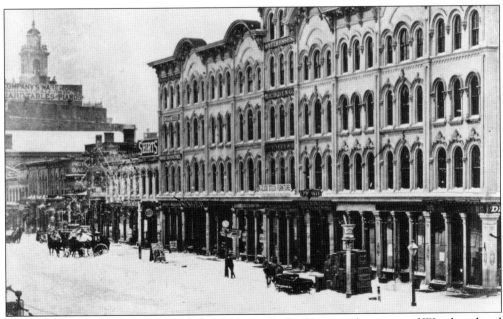

There is no date on this photograph, but it shows the building on the corner of Woodward and Grand River Avenues, where Ferry had his seed company. The son of a wagon maker, he was 74 years old when he died on November 11, 1907. (Courtesy of the Burton Historical Collection, Detroit Public Library.)

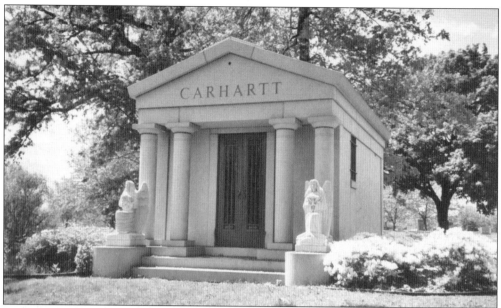

The Carhartt mausoleum overlooks Lake Woodmere. New Yorker Hamilton Carhartt, born in 1855, started a furnishing business in Grand Rapids. Later in Detroit, he manufactured overalls for railroad workers. The Carhartts were in a car accident on May 10, 1937. Hamilton's wife died that day. He died two days later. They were buried in a family plot until 2000, when their granddaughter had a mausoleum built in their honor in section North Lake.

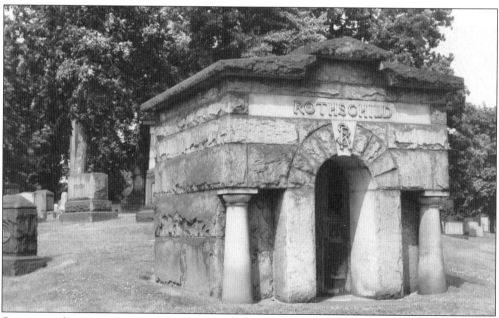

Starting in the cigar manufacturing business, Sigmund Rothschild died one of Detroit's wealthiest men on July 15, 1907, at the age of 71. The leaf tobacco business took him to Cuba, where he owned one of the most productive plantations. He was also involved with the Northwestern Mutual Life Insurance Company of Milwaukee and the Detroit Board of Commerce. He is buried in section NF.

Seymour Finney became a tailor in Windsor. Returning to Detroit, he went into the hotel business and the grocery business. Owning Finney House, he built a barn at State and Griswold Streets used as a station for the Underground Railroad and was a member of the common council. He was 85 years old when he died on May 26, 1899. His marker is third from left in the row of white headstones located in section A1.

Oscar Rosenberger was only 44 years old at the time of his death in New York on July 14, 1918. He was president and general manager of San Telmo Cigar Company, which became the largest cigar company in America. He was director of the United Jewish Charities in Detroit and a trustee of Temple Beth El. He is buried in section Beth El.

New Yorker James Vernor, the man who would become famous for his ginger ale that was "Aged 4 Years in Wood," made his way to Detroit in 1848. He ran errands for Higby and Stearn's Drug Store, where he was schooled in chemistry and pharmacy. How he developed his formula for Vernor's Ginger Ale is arguable. One account is that he created the formula while working at the drugstore and left a batch in an oak keg. Returning from serving in the Union Army, he discovered he had accidentally made a drink that was surprisingly different from anything he had ever tasted. The second explanation is that he thought about the formula while serving his four-year stint with the Union Army, then tried it out when he returned home. Regardless, it became a hit and he became rich. The old Vernor bottling plant built in 1954 was torn down. Vernor is buried in section D.

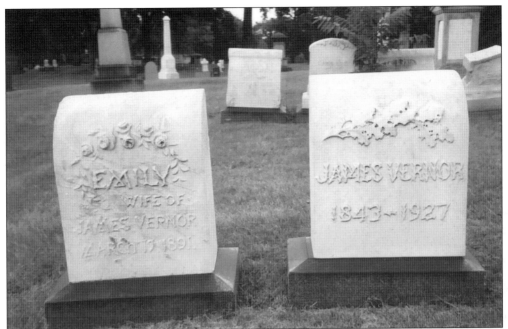

While Vernor served in the Civil War, he lost his right eye. His company captured Jefferson Davis, and Vernor himself was captured during a battle but was rescued. When he came home, he opened a drugstore selling his famous soft drink. He was a city alderman and a member of the city council. When asked to run for mayor and the U.S. senate, he refused.

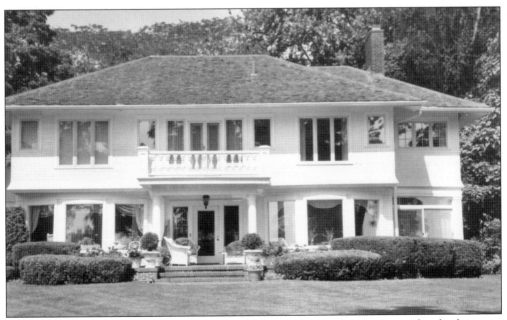

Vernor's wife died in 1891, and he remained a widow until his death in 1927, spending his last years living with his daughter. The old Vernor homestead in Detroit no longer exists, but his last home on Grosse Ile now has new owners. He died in the upstairs library of this home on October 29, 1927, at the age of 84.

Rabbi Leo Franklin devoted 42 years of service to Temple Beth El. Born on March 5, 1870, in Indiana and reared in Cincinnati, he died in Detroit on August 8, 1948. A graduate of Hebrew Union College, he became a spiritual leader for a Reform Judaism congregation in Detroit. He organized a Thanksgiving Day service, bringing Catholics, Protestants, and Jews together, and was director of the World Union of Progressive Judaism. He is buried in section Beth El.

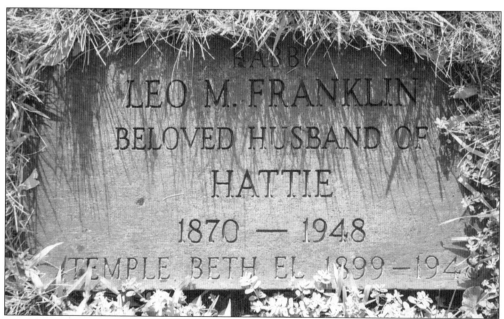

Franklin was a member of the board for the Symphony Society. He founded the Jewish Student Congregation at the University of Michigan and established the Jewish Welfare Federation of Detroit. He was commissioner of the Detroit Public Library and a member of the League of Nations Association of Detroit. Franklin was a writer and authored publications such as *Christ and Christianity from the Standpoint of the Modern Jew.*

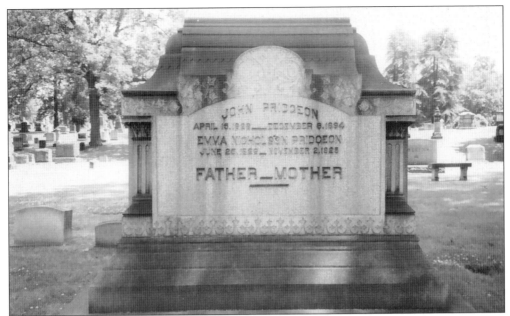

John Pridgeon, Detroit mayor from 1889 to 1890, was a councilman prior to being mayor and served as police commissioner. Among other positions, he was treasurer and director of the White Star Navigation Company and the Detroit and Milwaukee Railroad. His second marriage brought attention to him since he was distantly related to his new father-in-law. He died on March 16, 1929, in Massachusetts at the age of 76 and is buried in section F.

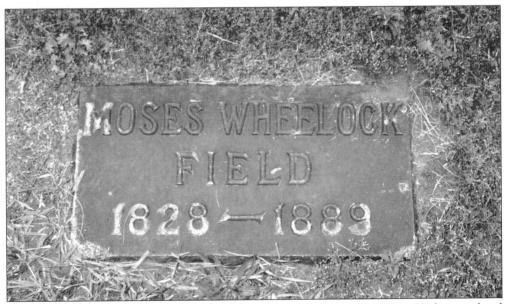

Moses Field, a Woodmere Cemetery founder, came from New York in 1844. He became head of a mercantile house, spent time in the farming and shipping industries, served two terms as alderman, and was elected to the House of Representatives. He flip-flopped between being a Republican and a Democrat and was a member of the University of Michigan Board of Regents. Dying on March 14, 1889, he was 61 and is buried in section D.

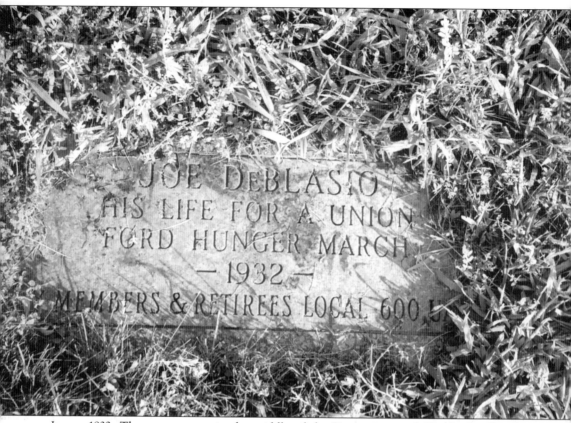

It was 1932. The country was in the middle of the Depression, and Charles Lindbergh was anxiously waiting for the return of his little son. On a very cold Monday, March 7 in Detroit, four men would lose their lives in one of the city's most deplorable demonstrations. Joseph Bussell, 16; Joseph DeBlasio, 31; Kalman Leny, just days shy of 27; and Joseph York, 20, marched with other Ford Motor Company workers to make demands from their employer. Meeting at Oakwood Boulevard and West Fort Street, they would cross the River Rouge bridge to Miller Road and then march toward the Ford employment office in Dearborn. Before they got to a bridge on Miller Road, Albert Goetz, a known Communist leader, reminded everyone to remain orderly as they continued to march. Meanwhile, 40 policemen were waiting for them. There was a Dearborn ordinance requiring parades to have a permit. This group did not have one.

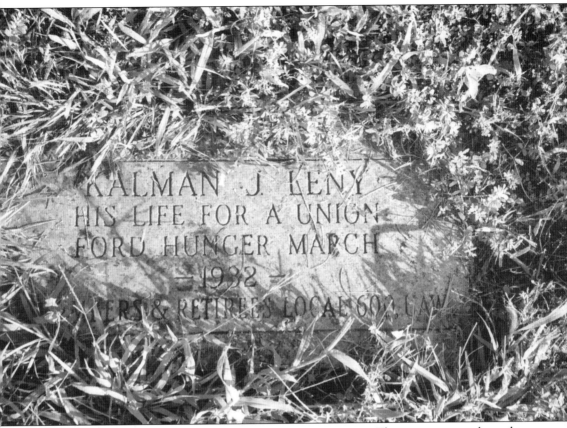

KALMAN J. LENY
HIS LIFE FOR A UNION
FORD HUNGER MARCH
1932
...ERS & RETIREES LOCAL 600 UAW

The police were told not to shoot but to use tear gas if necessary. The protesters, reaching the police, were asked where their leaders were. They said they did not know. Then they were asked for their permit. Someone yelled a permit was not needed, and that is when trouble began. Rocks, mud, and nightsticks were flying. Tear gas bombs burst, and the crowd retreated. The wind carried the fumes away, and the group resumed marching. Running out of tear gas, the police went back to Dix Avenue. Rock throwers continued hitting people and breaking windows. Firefighters arrived turning on water hoses. Harry Bennett, a non-union Ford employee, drove through the crowd getting hit by flying rocks. Waving his white handkerchief, he got out to address the crowd, and the mob moved his way. Bennett collapsed and was helped back into the car. Suddenly shots were fired. As to who shot first, the police or someone in the crowd, it is unsettled.

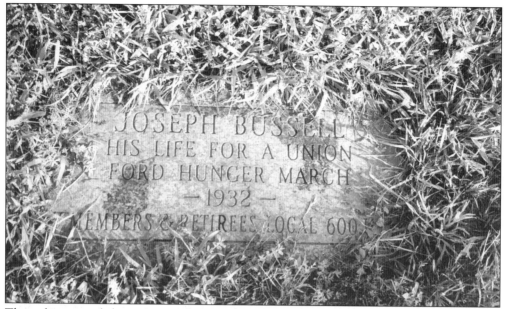

The police started shooting into the crowd, and the group dispersed. Many were injured by being shot or pelted with rocks. The following Saturday, the funeral procession entered the cemetery gate on Vernor Highway, close to the grave site where the four would be buried side by side. The service was under the Communists' direction. They were buried with a procession of about 8,000 people. Some carried banners promoting the Communist party and sang Communist songs. Some wore red ribbons marking their association with the Communist leaders. The hearse-led crowd passed hundreds who lined the sidewalks. Both Bussell and York were involved with the Young Communists, part of the Communist Party of America. The graves of the four men had no markers, so, years later, members and retirees of the Local 600 United Auto Workers bought headstones for them where they are buried in section Ferndale.

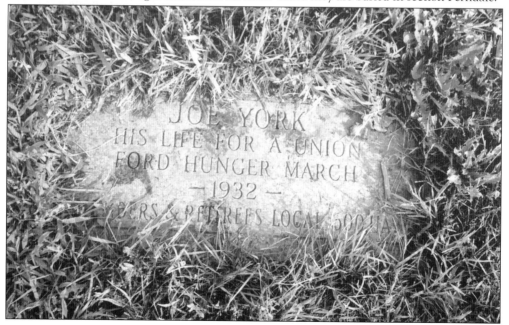

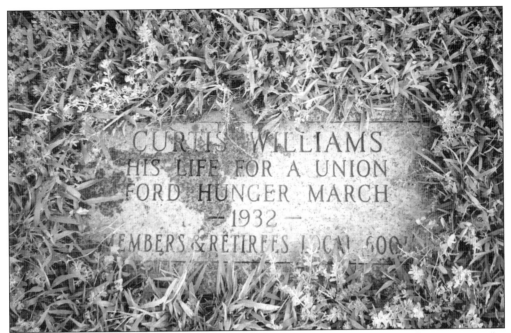

The United Auto Workers also placed a headstone on an empty space in the same row as the others for Curtis Williams, one of the marchers, who died on August 7, 1932, due to unrelated causes. Williams was cremated at Woodmere Cemetery, but his ashes were not interred there.

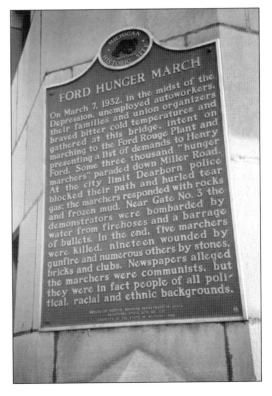

This plaque hangs on the River Rouge bridge as a reminder of the eventful day of March 7, 1932. The Communist ties with the workers led to little sympathy for them by some outsiders. Others understood the workers' plight and the Communist connection had little bearing. The day ended with each side blaming the other, both sides heavily injured, four men killed by .38-caliber bullets, and problems still unresolved.

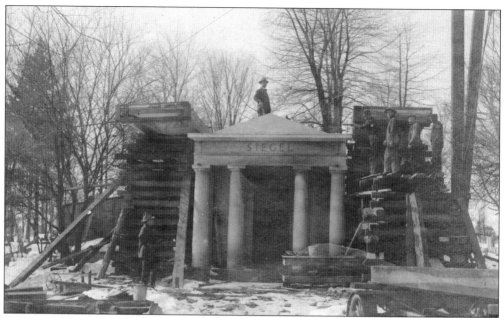

In July 1908, plans were approved for the Siegel mausoleum to be erected by Cartwright Brothers. Benjamin Siegel founded the B. Siegel Company, a women's clothing store. Jacob Siegel was the founder of the American Lady Corset Company. Being so specialized was not practiced at that time, but their plans worked and they became two of the most successful businessmen in the area. (Courtesy of Woodmere Cemetery.)

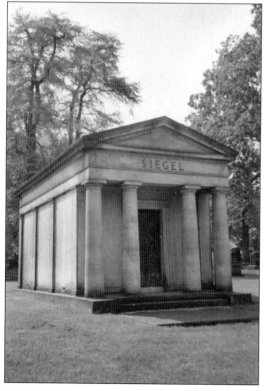

Jacob Siegel and Benjamin Siegel were German immigrants and distant cousins. They had this mausoleum built, located in section NF, which contains 24 crypts. Benjamin worked in a general merchandise store in Alabama before arriving in Detroit as a clothing store manager. He opened his own store in 1885.

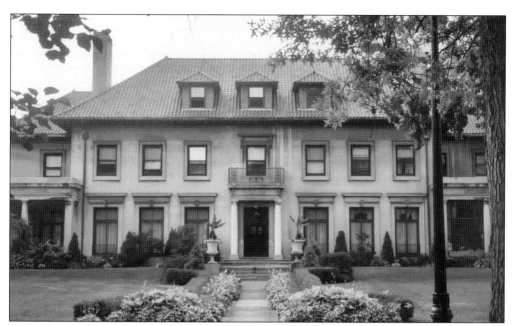

In Detroit's heyday, Boston Boulevard was the address for many leading businessmen and socialites. Once jewels of the city, many of the homes now exhibit peeling paint and overgrown lawns. The Kresges and Dodges were just a couple families living in this historic neighborhood. Benjamin Siegel, 150 West Boston Boulevard, had this 13,000-square-foot home designed by Albert Kahn. He died on November 11, 1936 at the age of 76.

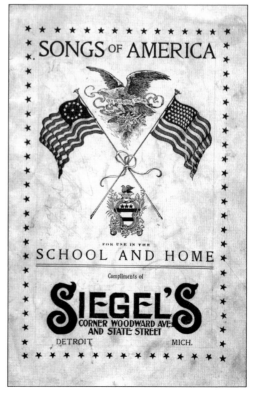

Jacob Siegel happened to attend the Ford Theater the evening President Lincoln was assassinated. His residence was at 51 West Boston Boulevard when he died on January 18, 1924, at the age of 82. He promoted patriotism and his store at the same time with this booklet distributed to parents and children. His message was "Whenever you can, come in with your mamma, and see the pretty things."

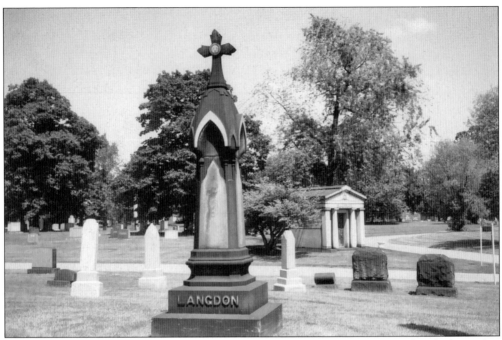

George Langdon was mayor of Detroit from 1878 to 1879. A month before Langdon died, another former mayor of Detroit passed away. There was quite a distinction between the two funerals. Mayor Maybury's was one of pomp and circumstance with thousands in attendance, but Mayor Langdon's had but a few mourners. He is buried in section B.

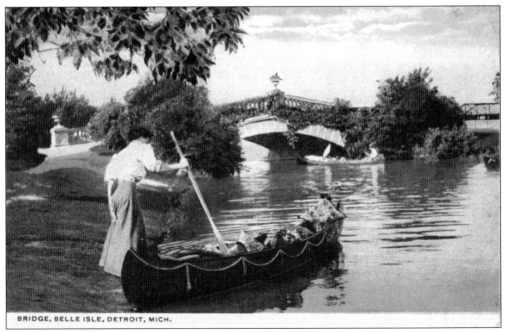

BRIDGE, BELLE ISLE, DETROIT, MICH.

Born in New York in 1833, Langdon died there on June 7, 1909. Langdon is best remembered for obtaining Belle Isle for the city. This postcard shows the bridge leading from the city proper to the island.

Joseph Black, a leading citizen of Detroit in the late 1800s, died on July 26, 1891. He was involved in businesses in Ohio, Kansas, and Michigan. Going from the wholesale dry goods to the banking business, he retired from the Bradshaw, Black, and Company. He still owned a sizeable estate in Zanesville, Ohio, and several business blocks in Topeka, Kansas, when he died. He is buried in section L.

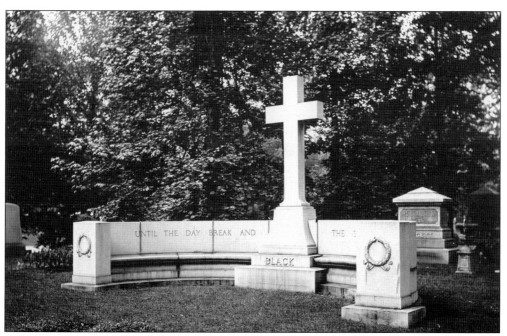

This earlier photograph of this now blackened, atypical monument displays a popular inscription used on markers, "Until the day breaks and the shadows flee away." This particular engraving has an omitted *s* at the end of the word *break*. (Courtesy of Woodmere Cemetery.)

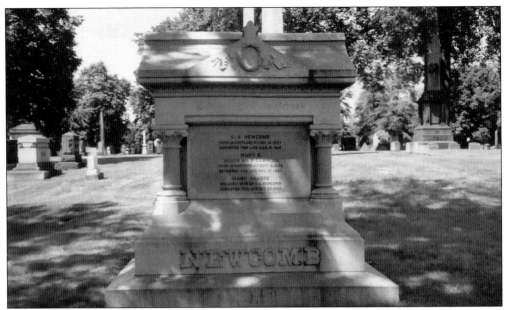

Cyrenius Newcomb founded the Newcomb-Endicott Company and was vice-president of the Anderson Electric Car Company. Starting as a retail clerk in New York, his home state, he became a partner in the dry goods business of N. H. Skinner and Company in Massachusetts before moving to Detroit. He zealously supported the cause of temperance. He died on March 9, 1915, at the age of 78 and is buried in section F.

Cyrenius Newcomb Jr. was executive vice-president of First Detroit Bank and was involved with the Bankers' Securities Company. Around 1930, the vicinity surrounding lower Woodward Avenue had "been the shame of the city." He had the waterfront cleared and civic administration buildings erected. He was president of his father's business, which was bought by the J. L. Hudson Company in 1927. He died on February 18, 1951, when he was 80 years old.

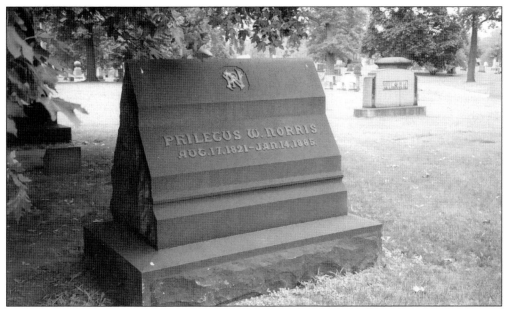

Philetus Norris, superintendent of Yellowstone National Park from 1877 to 1882, created roads, collected specimens for the Smithsonian Institution, and wrote a guide for Yellowstone National Park visitors. Born in New York on August 17, 1821, he moved to Williams County, Ohio, in 1842, founding a place called Pioneer. He served as a spy and captain of scouts during the Civil War and served in the Ohio House of Representatives. His gravestone is in section H.

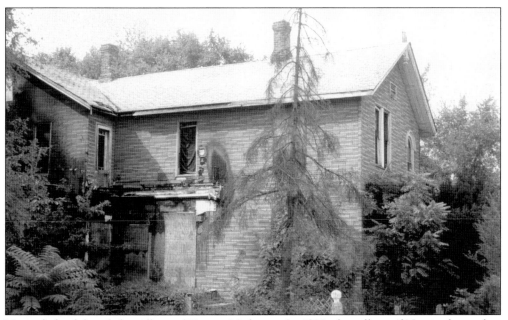

Norris helped found the village of Norris, Michigan. In 1890, the village of Norris changed to North Detroit and later to Hamtramck. Norris died on January 14, 1885, in Rocky Hill, Kentucky. His remains were buried at Woodmere Cemetery on May 2, 1886. Norris's Victorian-style house on Mount Elliot is sorely neglected. The house, built in 1870, is in what had been a German Lutheran neighborhood.

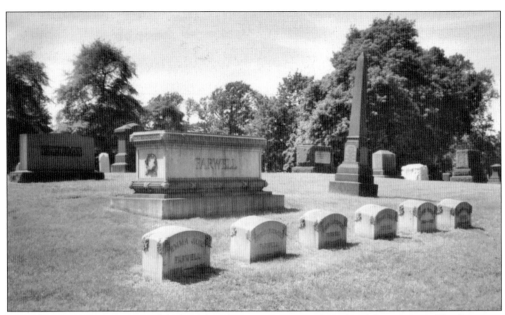

On July 4, 1889, Jesse Farwell helped lay the cornerstone of a school he gave to Charlestown, North Carolina. Born there, he was an undertaker apprentice in New York. Moving to Detroit, he became an undertaker. He was involved with the Ironizing and Paving Company, Clough and Warren Organ Company, and Dominion Organ and Piano Company. He established Farwell Transportation Company, which grew into a fleet of 20 ships. His company, Collins and Farwell, excavated the American Soo Locks, and with his son George, he helped build New York's aqueduct. Vacationing in his hometown, he decided to have a new two-room school built. Dedicated in 1890, it still stands today. Shortly before Jesse's death on September 19, 1904, at the age of 70, his son Jeremiah committed suicide. This left George to continue on with the businesses. He helped build the first subway in New York City and helped produce the tunnel running under the Niagara River in New York. The first automobile showroom is attributed to him. On December 6, 1921, he died at the age of 58 and was buried in section B.

David MacKenzie died on July 16, 1926, at the age of 64. A University of Michigan graduate, he became a teacher in Fenton and later worked in the Flint school district before becoming principal of Detroit's Central High School in 1904. He was highly praised for running one of the largest populated high schools in the United States. He is buried in section G.

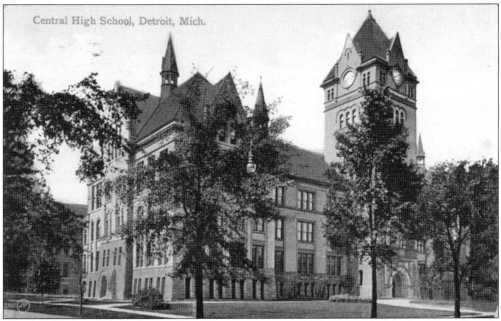

Central High School and Junior College shared the same building, and MacKenzie managed both. Junior College became the College of the City of Detroit, with MacKenzie being dean. This institution became the seed for Wayne State University. MacKenzie gave tuition money to disadvantaged students, stipulating the loan was to be paid back when the student was able.

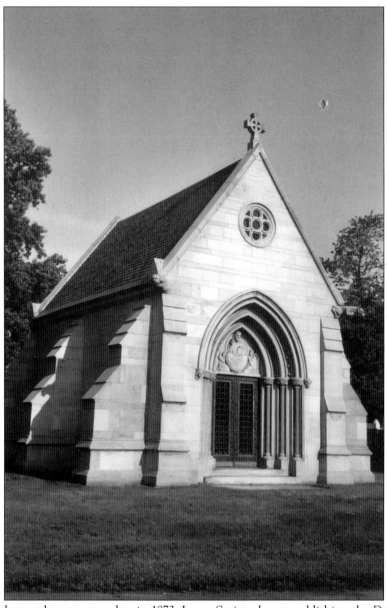

Detroit had several newspapers, but in 1873, James Scripps began publishing the *Detroit News*. James was born in London on March 19, 1835. His father brought the family to Illinois, and James attended college in Chicago. He worked as a bookkeeper for a lumber company, and then a proofreader at the *Chicago Tribune*. He then became a reporter, but tough times caused his lay-off. Failing at gathering and selling sheep pelts in Chicago, he made his way to Detroit, becoming a *Detroit Advertiser* reporter and then a news editor. Buying and combining the *Detroit Tribune* and *Detroit Advertiser,* he almost went bankrupt. Pulling out of debt, he started enterprises in Cleveland, Akron, Toledo, and other major cities. On May 29, 1906, he passed away with his casket displayed in his favorite room, the library. The Scripps chapel-like mausoleum was designed with no crypts, allowing all the bodies to be buried beneath the floor. Anyone wishing a chapel service could use his mausoleum. In 2000, the 13th-century English Gothic structure, built in 1887 and located in section A5, was rededicated with $40,000 spent to restore it.

Scripps was a founder of the Detroit Museum of Art and donated his own collection of paintings. In 1902, he became a state senator. Scripps donated property across the street from his home to be used as a public park.

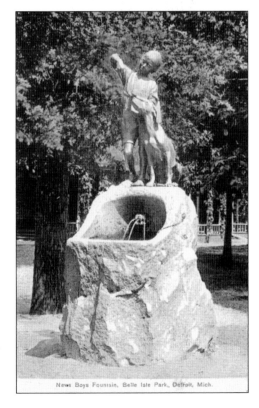

News Boys Fountain, Belle Isle Park, Detroit, Mich.

Scripps donated this $3,500 Newsboy drinking fountain to the city. On July 6, 1897, it was ceremoniously unveiled on Belle Isle. Attended by his dog, the young boy is dropping coins into his hand while holding newspapers under his arm.

David Richardson, leaving an estate of about $1.5 million, died on September 25, 1889, at the age of 63. His match company suffered losses. Experiencing fierce competition, the firm merged with Diamond Match Company. Owning about 800 acres of land near Concord, New York, his birthplace, he continued to raise cattle. He served as state senator from 1873 to 1874 and was a member of the board of education. He is buried in section A5.

David A. Brown, founder of the Old Newsboys and president of the Goodfellows, was remembered for his charitable work in all faiths. Born in Scotland in 1875, he came to the United States, finding success with Brown and Brown Coal Company and People's Ice Company. His presidency of General Necessities Corporation and the Brownie drugstore chain made him one of Detroit's wealthiest people. He died on December 22, 1958, and is buried in section Beth El.

Maj. Rufus Jacklin, age 64, was running for the Democratic nomination for city treasurer when he died on September 14, 1906. He enlisted in the Union Army, rising from private to full major brevet lieutenant colonel. Captured by the Confederates twice, he escaped the first time and then was rescued by General Custer. He participated in many battles, including Bull Run. After the Civil War, he started a hardware business. He is buried in section F.

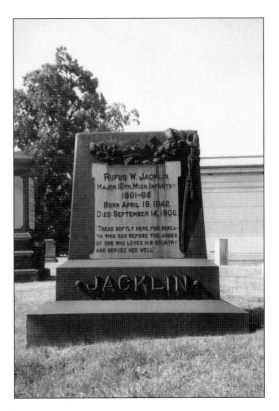

Conrad Ten Eyck, who died in 1847 and was buried in Dearborn, was moved to Woodmere on October 10, 1878. Born in New York, he moved to Detroit in the early 1800s. He became a fur trader and later opened the Ten Eyck Tavern in Dearborn. Business boomed as travelers came for a respite from Detroit. He was sheriff of Wayne County, a member of the state legislature, and a U.S. marshal. His grave site is in section F.

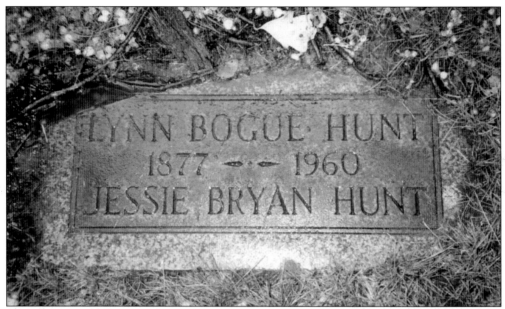

Lynn Bogue Hunt died on October 13, 1960. Born in 1877 in New York, he used to draw birds and animals as a child. He came to Michigan, studied at Albion College, and became an artist for the *Detroit Free Press. Field and Stream, Saturday Evening Post,* and other magazines utilized his paintings on their covers. Nineteen of his paintings were used on National Wildlife Federation stamps. He is buried in section I.

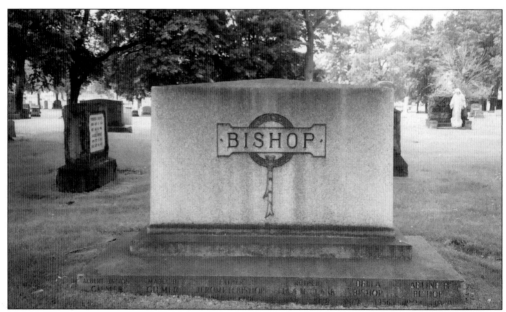

Five-term Wyandotte mayor Jerome Bishop died on May 22, 1928. He served Decatur School District as superintendent before moving to Wyandotte to become its first superintendent and helped establish the library. He began manufacturing rugs and coats, and his business boomed until World War I, when no one could afford to buy his merchandise. The company folded, and the city bought his property, naming it Bishop Park. His burial site is in section F.

Detroit native Rufus Gillett Lathrop was born on April 7, 1872, and died on November 4, 1937. He served as secretary of the Woodmere Cemetery Association and was an attorney and secretary of the Street Railway Commission. He attended the University of Michigan, earning his law degree, and practiced his skills for 26 years. His grave is in section D.

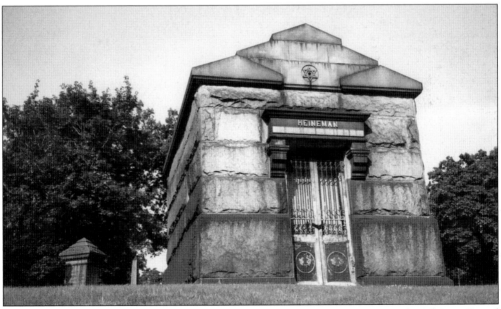

David Heineman, a member of the Michigan legislature, Detroit City Council, and State Board Library Commission, was instrumental in the development of the Belle Isle aquarium, Detroit Institute of Arts, and Detroit Public Library. He held key positions with Fort Wayne and Belle Isle Railway Company and Detroit Fire and Marine Insurance Company and designed the city of Detroit's flag. At the age of 69, he died on February 21, 1935, and is buried in section NF.

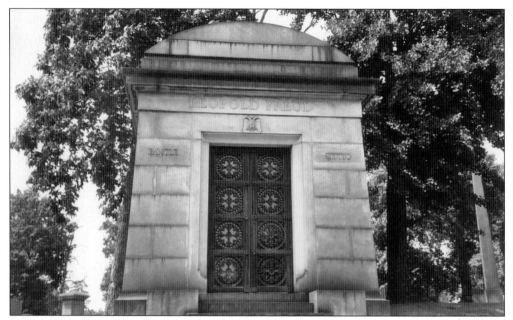

Leopold Freud joined his father in the general merchandise business in Keweenaw County. He moved to Detroit in 1878, involving himself in real estate and investment securities, and became a member of the Detroit Board of Commerce, the Harmonie Society, and the Detroit Real Estate Board. Dying on December 13, 1914, he was 66.

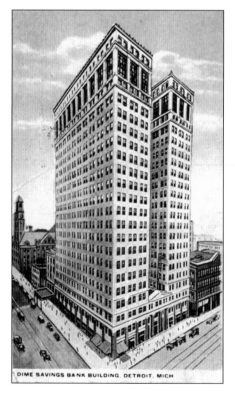

DIME SAVINGS BANK BUILDING, DETROIT, MICH

Leopold Freud conducted his business in the Dime Savings Bank building pictured here in this early postcard of Detroit. He lived in Detroit but his summer home was in Grosse Pointe. His son, Jerome, a well-known attorney, died on August 11, 1942, during a lawsuit trial in Chelsea. They are entombed in section NF.

Isaac N. Swain grew up in poverty in New York, giving him the willpower and determination to have a better life. He became a successful teacher. He owned a large lumber mill in Watervliet and owned and managed one of the largest flour mills in Michigan. He was 72 years old when he died on May 1, 1880. He is buried in section A5.

Frederick Matthaei, founder and president of American Metal Products Company, served in the United States Navy during World War I. He donated his 800-acre estate to be used for a University of Michigan golf course and the botanical garden that bears his name. He also donated money for the establishment of an animal shelter and the Evangelical Home for Children and Aged. At the age of 80, he died on March 26, 1973. He is buried in section A5.

Alexander Y. Malcomson, emigrating from Scotland, started as a grocery clerk. He found his fortune in the wood and coal business. For a time, he was in partnership with Henry Ford but ended the relationship before Ford Motor Company became prosperous. He died on August 1, 1923, at the age of 58 and is buried in section H.

Malcomson did not like Henry Ford's idea about building a cheap car, so Malcomson's partnership ended with Ford buying him out for $150,000. He created the Aero car, a four-cylinder air-cooled luxury car, but it did not do well. He left the car industry and reaped the rewards of real estate investments and the building supplies industry.

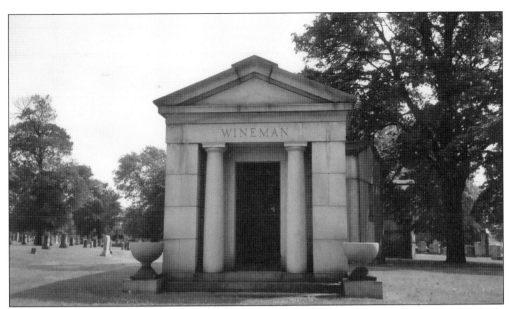

Born on November 20, 1852, Cincinnati native Leopold Wineman came to Detroit in 1893 and founded a furniture store, People's Outfitting Company. He allowed customers to pay on the installment plan, and the idea caught on with other merchants. Wineman served as president of Victor and Company, a furniture dealer in New York. He died on April 21, 1923, at the age of 70 and is buried in section Beth El.

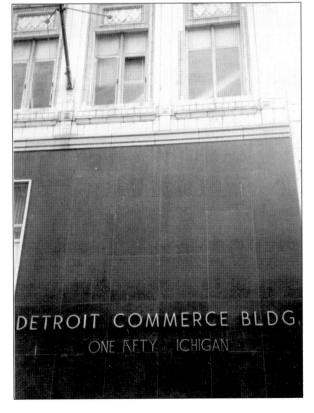

After Leopold's death, his sons ran the company. Henry was president but relinquished that position to Andrew when he became chairman of the board of directors. They ran three stores, including this one on Michigan Avenue. Andrew was active with the Detroit Institute of Arts. Henry was involved with the Detroit Roundtable of Catholics, Jews, and Protestants. Andrew, age 74, died in 1954, and Henry, age 78, died in 1957.

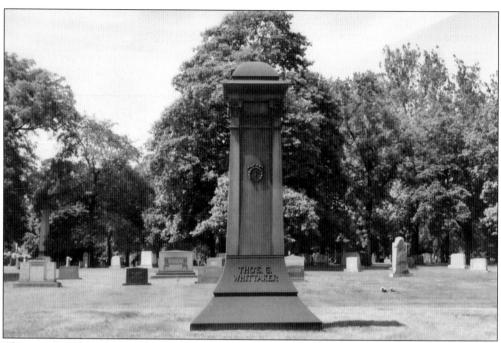

Thomas G. Whittaker, at the age of 83, was the oldest living past commander of the Detroit Commandery No. 1, Knights Templar. His monument sets in a triangular plot near the entrance of the cemetery located across from section Park View.

Whittaker's monument would replace the flower bed on the left when he died on October 19, 1933. James Findlater's monument is on the right. In the distance is the Rowe mausoleum on the left. (Courtesy of Woodmere Cemetery.)

His career began in Canton, Ohio, when he opened a store with his brother, but later Samuel X. Gaylord moved to Michigan and established a department store in Detroit. It was sold to Crowley, Milner, and Company, and he became president of the Miles Theater Company. At the age of 76, he died on November 16, 1939, and is entombed in section Beth El.

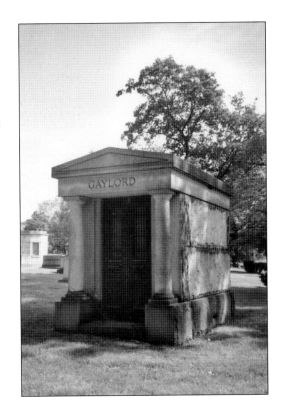

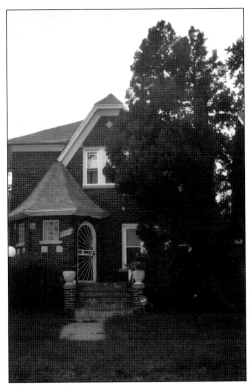

At home in 1933, Gaylord and his grandson were tied up and robbed at gunpoint, losing about $5,000 worth of jewelry. A couple days afterward, a man tried to extort $1,000 from him but was apprehended when he tried to collect the money that had been left in a tin can in an alley.

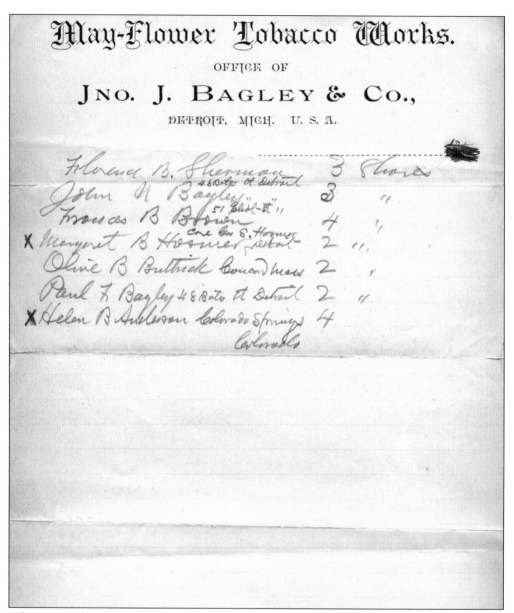

May-Flower Tobacco Works.

OFFICE OF

JNO. J. BAGLEY & CO.,

DETROIT, MICH. U. S. A.

Florence B. Sherman — 3 Shares
John N. Bagley 48 Bates St Detroit — 3 "
Francis B. Brown 51 Eliot St " — 4 "
X Margaret B. Hosmer care Geo E. Hosmer Detroit — 2 "
Olive B. Buttrick Concord Mass — 2 "
Paul F. Bagley 48 Bates St Detroit — 2 "
X Helen B. Anderson Colorado Springs Colorado — 4

Whatever made Arthur Pierce think he could forge a check with John Bagley's signature, a man so well-known, is beyond anyone's comprehension, but that is exactly what Pierce did in September 1874. He was released on his own recognizance. On July 27, 1881, Detroit lost that man so well known and adored by many. John Judson Bagley, a Michigan governor from 1873 to 1877 and president of Woodmere Cemetery from its inception until 1875, died. A New Yorker, he became an apprentice in the chewing tobacco business and concocted his own tobacco brand, May-Flower. Business boomed with buyers the world over. His first venture toward becoming a politician arose when he became a member of the board of education. He served on the common council and was on the police board when he ran for governor. During his second term, Bagley's health started to turn. Constantly on the go, he took no time for himself and died at the age of 49. After Bagley's death, stock was transferred to some of his heirs. (Courtesy of Woodmere Cemetery.)

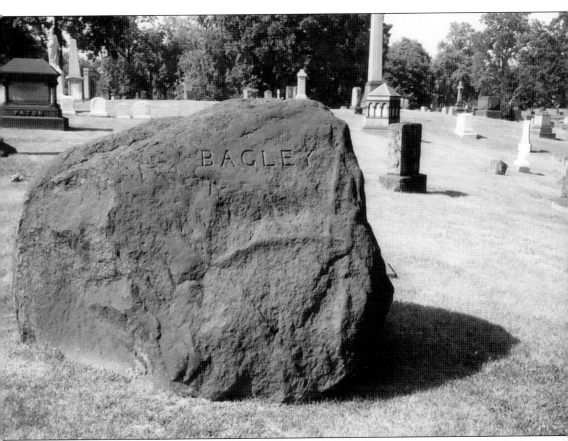

"I have not lived long; but I have lived a great deal too much. I was managing an extensive business before I was much more than a boy. Indeed, I had no boyhood. I skipped it. I sprang from childhood into the cares and work of middle age, and have never taken a holiday. I had done the work of a long life before I was 30, and now I find myself spent before I am 50, although I started with a capital of vitality that should have lasted me till 80." The huge granite boulder, in section D, is as it was found. It was Bagley's request that it be brought to Detroit from the Mackinac area. Over 30,000 people attended his funeral, and flags were lowered across the state. Businesses closed so employees could attend his funeral. Tobacco manufacturers from Cincinnati made the trip to honor the man "who by his high sense of honor and justice, his strict integrity, and his fine moral and social qualities, has spread an excellent influence over the whole trade."

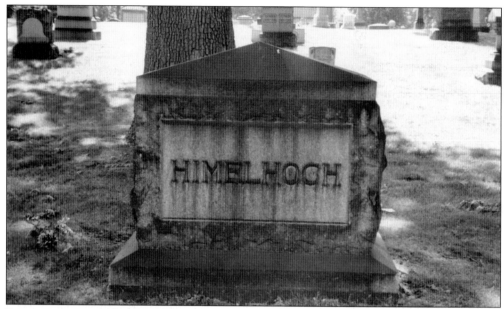

Russian immigrant Wolf Himelhoch, about 28 years old, came to America in 1873. He lived in Bay City and Caro for 30 years before opening his mercantile business in Detroit. After his death, his sons Israel, Herman, and Zella held various positions in the company, now called Himelhoch Brothers and Company. Wolf died in 1922, Zella in 1928, Herman in 1943, and Israel in 1973. They are buried in section NF.

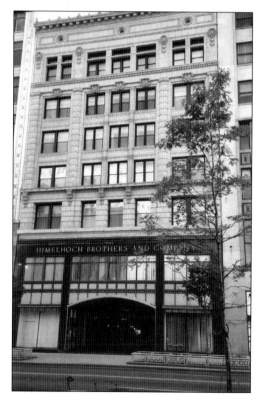

No longer in business, the Himelhoch Brothers and Company store still stands on Woodward Avenue. Many stylish women counted on its reputable merchandise and great service. The company was one of the first specialty stores that helped modernize the retail business.

John and Joseph Greusel, father and son, were alternate delegates to the Republican National Convention. John, a senator and state representative, was in the brick-making business. He helped expand the city limits by acquiring annexations. Dying on October 31, 1886, he was 77. Joseph, a state representative, senator, political reporter for the *Detroit Free Press,* and legislative correspondent, died on February 13, 1913, at the age of 76. They are buried in section G.

James Findlater's plaque that lies beneath his monument testifies to his allegiance to the Masons from 1862 to 1893. He started in the stonecutting business; worked for Clark Shipbuilding Company, which later became the Detroit Shipbuilding Company; and spent some time in the undertaking business. He died on June 13, 1891, at the age of 71. His monument is in section Park View. (Courtesy of Woodmere Cemetery.)

Martin Snyder Smith, coming from New York in 1851, became a jewelry store clerk. He started his own jewelry store, M. S. Smith and Company, and joined the lumber firm, Alger, Smith, and Company. He was president of American Eagle Tobacco Company and the Michigan Condensed Milk Company, and treasurer of Woodmere Cemetery. At 64 years old, he died on October 28, 1899. His spectacular monument is hidden behind the trees in section D in this early photograph. (Courtesy of Woodmere Cemetery.)

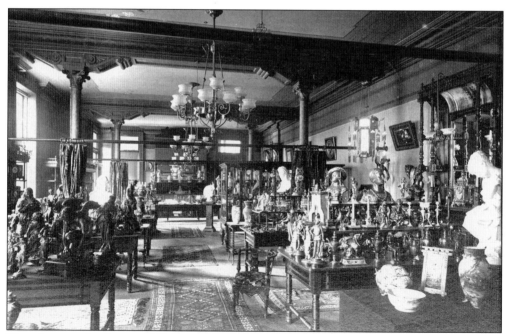

This photograph taken in 1885 shows the second floor of the M. S. Smith and Company jewelry store that was located on Woodward Avenue and State Street. Carrying everything from earrings to statues, this store was one of the most elegant of its kind. (Courtesy of the Burton Historical Collection, Detroit Public Library.)

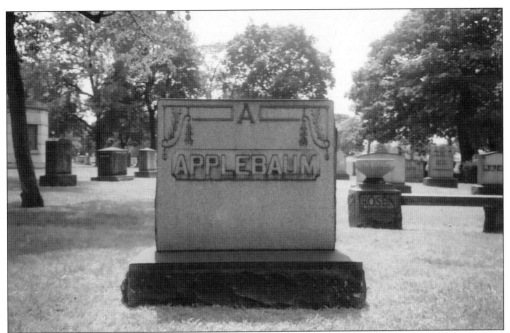

Known for his real estate deals and railway supply manufacturing company, Isaac Applebaum died on May 30, 1928, at the age of 74. He came to New York from Poland without a cent. He worked as a butcher and then bought and sold machinery. He is buried in section Beth El.

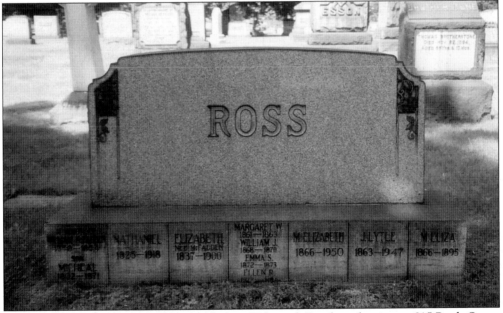

In 1883, Nathaniel Ross moved his family from Telegraph Road to what is now 915 Brady Street in Dearborn. The abandoned Detroit Arsenal of Dearbornville was sold at auction. Ross won this former arsenal powder magazine, and it became their new home. Daughter Lizzie resided there until her death on December 30, 1950. Willing the home to Dearborn, it is a museum and research facility. The family plot is in section N. (Courtesy of Tom Koselka.)

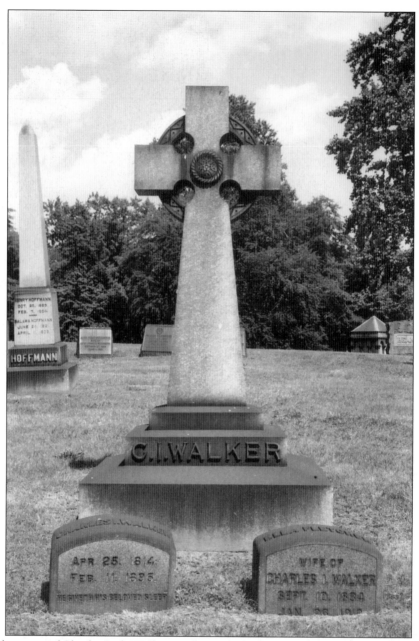

In the obituaries of Charles Irish Walker, nothing is said about his involvement with Woodmere Cemetery. He was one of the influential men who decided Detroit needed a new cemetery, serving on Woodmere's board of directors as secretary until July 18, 1893. With his health declining, he passed away on February 11, 1895. Born in New York on April 25, 1814, he was one of 13 children. At 16, he became a teacher and then moved to Grand Rapids, working as a land and investment agent. In his lifetime, he was a justice of the peace, owner and editor of the *Grand Rapids Times*, member of the state legislature, an attorney, a University of Michigan law professor, a judge, and an author. He was also instrumental in framing the state constitution for Michigan. He served on Detroit's board of education and served on the Historical and Pioneer Society board. He is buried in section D.

The Penobscot building, named for a river in Maine, was built by Simon Jones Murphy. Originally from Maine, he started a lumber firm with Jonathan Eddy in Michigan in the 1850s. Newell Avery joined them and began purchasing pinelands, with Eddy dying a short time later. Valued employees were given part of the business. Once all the timber was forested, Murphy sold the land to settlers. When he died on February 1, 1905, at the age of 89, he had been director of the American Exchange National Bank, Michigan Fire and Marine Insurance Company, and the Standard Life and Accident Insurance Company. Avery became mayor in Port Huron. He owned other mills and real estate that made him one of the wealthiest Detroiters. He ran for the legislature but was defeated. He died on March 13, 1877. He is buried in section F.

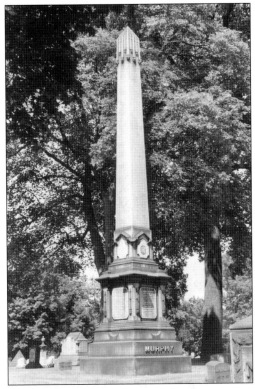

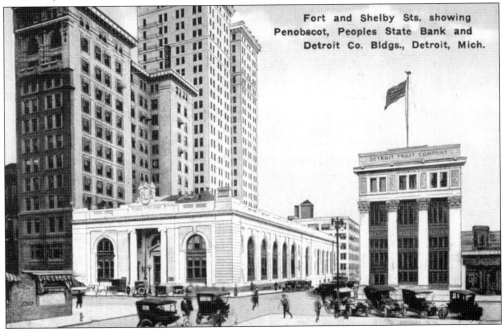

Fort and Shelby Sts. showing Penobscot, Peoples State Bank and Detroit Co. Bldgs., Detroit, Mich.

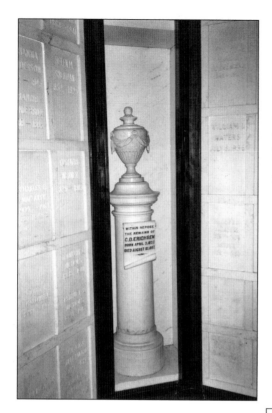

Dr. Hugo Erichsen graduated in 1882 from Detroit Medical College, now known as Wayne State University. He founded the Michigan Cremation Association and was president of the Cremation Association of America from 1913 to 1916. He was a physician, a reporter for the *Detroit News* and the *Detroit Journal,* and an editor for the magazine *American Boy.* He died on October 10, 1944, and was cremated at Woodmere's crematorium. His ashes are in a niche located in the columbarium.

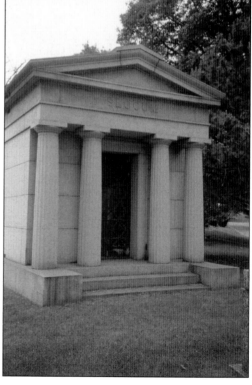

Gilis Bryan Slocum arrived in Detroit in 1831 and helped found Toledo, Ohio. He set up a store in Newport, Michigan, and then moved his business to Trenton. His interest in railroads built the Toledo and Canada Southern. He lived in Trenton where Elizabeth Park is today. He died in 1884 at the age of 75, but was not buried at Woodmere Cemetery until April 20, 1917, in section North Lake.

Ozias Shipman found wealth in the coal business. Going from his New York birthplace to Waverly, Pennsylvania, he opened a grocery store. In 1870, the Erie Railway workers went on strike and he suffered the wrath of angry strikers and his store was burned. Following short stays in New York and Utah, he ventured to Detroit, setting up a coal business. He died on January 28, 1898, at the age of 63 and was buried in section D.

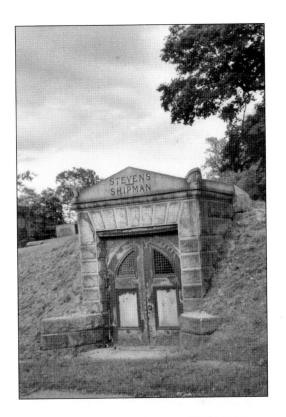

Capt. John Stevenson, a steamboat owner, served Michigan in the House of Representatives for five terms. He came from Scotland, having been a teacher at 13. When he was 17, he came to the United States operating steamboats running between Detroit and Canada. He served on the common council and the Wayne County Board of Supervisors. He died on January 9, 1937, at the age of 83. His grave is in section B.

Daniel Scotten, a member of Woodmere Cemetery Association, was a competitor of John Bagley in the tobacco business. Dying on March 3, 1899, the *Detroit News Tribune* reported, referring to his monument in section North Lake, "It is far from the hundreds of other tombs in the cemetery, standing in dignified loneliness; it is as simple as was the man, and it appears unapproachable, as he appeared to many in life." (Courtesy of Woodmere Cemetery.)

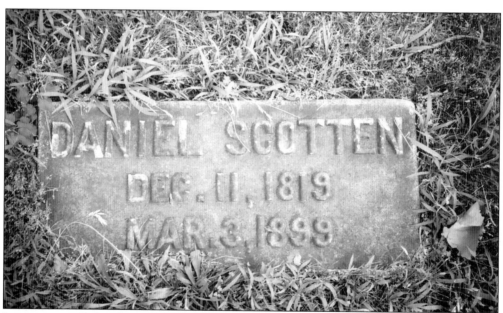

Leaving no will, his $7 million estate would "let the law take its course." Each of his five employees received a house, his three sisters received lifelong care, and his wife and daughter received the residue. The builder of the Cadillac Hotel, Scotten feared trains and streetcars. He bought clothing and hundreds of blankets to distribute each winter, and raised fowl and vegetables that were given to the poor.

Michael Vreeland died on January 18, 1876, but was not buried at Woodmere Cemetery until October 6, 1911. A farmer living in Brownstown, he enlisted in 1861 to be part of the Civil War and was promoted to brigadier general. He fought with the 4th Michigan Infantry Volunteers at Bull Run, Antietam, Malvern Hill, Fredericksburg, and Gettysburg. Wounded at Gettysburg, he was promoted to brevet brigadier general. He is buried in section South Lake.

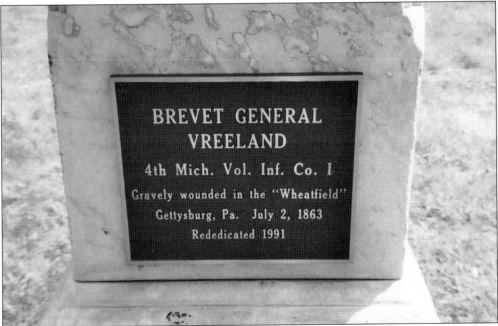

His monument needed restoration, so the 4th Michigan Regiment Company I reenactors took it upon themselves to repair it. In a dedication ceremony held in 1991, the reenactors revealed a plaque they had mounted on the back of the monument.

On August 16, 1896, Woodmere Cemetery entered into an agreement with Col. M. I. Ludington, assistant quartermaster general of the United States, for the sale of 10,000 square feet to be used for burial space for soldiers. From November 25 to December 2, 1896, 156 bodies, 34 of them unknown, were reinterred at Woodmere from Fort Wayne's cemetery. The cemetery had fallen to decay and the records were in shambles, so the bodies were moved to Woodmere. The flagpole was given "In memory of our soldiers, sailors, and marines" by the Detroit Memorial Day Association of 1926. The flagpole divides the GAR section on the left from the U.S. Army section on the right. In 1910, Woodmere contributed $5,000 to the Infantry Veteran Association toward the monument.

Three

NEXT–DOOR NEIGHBORS

Woodmere Cemetery, famous for the many notables buried there, has a greater number of those most have never heard about. For some, their deaths earned them a couple paragraphs in the local newspaper announcing their demise, but were quickly forgotten by the reader in a day or two. Many lay unclaimed in the morgue until the city buried them. Some were interred in the single grave sections and later moved when money was saved to purchase a family plot.

Some have unmarked graves, which is the case of Amelia Buck. According to newspaper accounts, Amelia Buck, 71, lived with her sister, Matie, 67, when Amelia died. Matie did not tell anyone because she thought by praying, Amelia could be raised from the dead. Every day Matie attended to her dead sister by washing her body and trying to give her a little coffee. She dressed her up and sat her on their front porch because she wanted Amelia to see the Fourth of July parade. It was not until Matie wrote a letter about Amelia's death to the pastor of a local church that the authorities stepped in and took Amelia to the morgue. Amelia was declared dead on July 27, 1952. She was buried on September 15, 1952, in section West Ridge.

There was a time when a rain barrel was found in everyone's yard. For little two-year-old Frank McDonald, it was something to explore. He fell into his family's barrel on May 4, 1871. After he was found, every attempt was made to revive him. The small headstone standing up in the lower right-hand corner in the family plot marks his grave in section D.

In 1930, Georgians Archie and Maude Powers began life together. Establishing a family of seven children, Archie left for Detroit, secured employment with Chevrolet Gear and Axle, purchased a duplex, and waited for Maude. Packing memories, household goods, and children, she joined Archie. Often they enjoyed a picnic lunch by Lake Woodmere and walked the paths. Archie, 74, died on September 4, 1981. Maude, 93, followed on March 8, 2001. They are buried in section Cresthaven.

George Paine was born in 1842 to parents who owned several hundred acres near Monguagon Creek. Raising hogs and chickens, he moved to Wyandotte, spending his days dabbling in his study of perpetual motion. He told how area Native Americans would dine at his family's mansion, and he owned a silver watch supposedly worn by the Duke of Wellington at the Battle of Waterloo. He died on April 24, 1928, and was buried in section B.

Milton C. Lightner, the first rector of Grace Church in Detroit, died in California on July 1, 1880, at the age of 59 but was brought back to Detroit for burial in section F. The *Detroit Free Press* noted his death and said many "will be painfully shocked by this news of his unexpected and sudden taking off."

William Garrison, known as "Doc" in the Wyandotte community, was totally blind and formed a drug company with his brother-in-law. He was also a skilled piano tuner. He was a widow at the time of his death on May 10, 1935, at the age of 73 and was buried in section Wildwood.

A despondent mother poisoned her one- and three-year-old babies on September 26, 1899. The mother was opposed to cremation, and her husband promised the children would not be cremated if the children died before them. A conversation took place that he favored cremation. She was horrified and took their lives. The Rheiner children, not cremated, were buried to the right of this monument in section F without their mother in attendance three days later.

Fred Schwankovsky was about to move his piano and organ store on Monroe Avenue to Woodward Avenue when his three-year-and-one-day-old daughter, Margaret, died on August 19, 1891, from scarlet fever. In March 1915, there were at least 100 reported cases each week. Health officer Dr. William Price remarked that the numbers were not any different from the previous year at that same time. Margaret is buried in section H.

A disease wiping out all the children in one family was not unusual. Adolph Rode and his wife buried their 10-year-old daughter, Clara, on March 28, 1906, next to their other two daughters, Marie, two, and Matilda, eight, whom they buried on March 21 in section A2, all due to scarlet fever.

Quintessential of baby burials, little headstones bearing lambs or sometimes flower-bearing cherubs are seen all over Woodmere Cemetery. Three-year-old Gilbert Mastin's life was taken prematurely when he could not overcome being weakened by meningitis on October 17, 1876. He is buried in section D.

"I had a little bird its name was Enza. I opened my window, and in-flu-enza." In 1918, chanting children skipped rope. A war was ending. The reason that many soldiers did not return home was not because of enemy fire, but because of influenza. Theaters, churches, poolrooms, and movie houses were ordered closed. Helen Morley, a 19-year-old bride, developed influenza and suffered a miscarriage. Mother and baby, buried together in section N, died on October 13.

Everyone had seen the ravages of scarlet fever, smallpox, and other diseases. When one epidemic passed, another was waiting around the corner to attack. Seventeen-year-old Annie Menzies is buried between her parents in section D. She lost her life to typhus fever on November 24, 1870.

Although dead, two-year-old Herbert Rowden was part of a custody battle. Dying on October 16, 1924, his quarantined parents let relatives bury him in their plot. Agreeing he would be moved when the parents purchased their own plot, the relatives reneged, refusing to allow Herbert to be reburied. In court the judge ruled in the parents' favor. Herbert was reburied in this plot in section Fernwood on October 21, 1925.

It is too late to determine who made the mistake that caused Ellen Karman's name to be misspelled when she died in 1901, and no one had George Karman's death date of 1921 inscribed on the headstone located in section A2. (Courtesy of Tom Koselka.)

The Ten Commandments on the Lucas marker in section West Ridge makes it easy to spot. Jack Lucas, a tavern owner in Lincoln Park, was born in Greece, moved to Cleveland, and then to Detroit. He worked as a maitre d' before going into business for himself. He died on October 10, 1954, at the age of 61.

Karl and Elizabeth Brandt immigrated to Canada after getting married in Risewald, West Prussia. About eight years and five children later, they found their way to Detroit, adding three more children to their family. Karl hired on as a switch tender for the Michigan Central Railroad Company. If they were not attending school, his children would bring his lunch to him. He passed away on November 19, 1916, at the age of 74. Elizabeth was a midwife and helped the local undertakers by washing and preparing bodies for them. Elizabeth, age 87, died on September 30, 1935. Both are buried in section R.

On July 13, 1888, William Baby lost his life after he was pinned under a derailed train engine and was scalded to death by the steam. Working as a fireman for a railroad company, he was 30 years old and left a wife and an infant daughter. He is buried in section A1.

Orson Burnett, 45, owned a double-barreled gun and sold it to Jim Norris. On May 18, 1874, Burnett visited Norris to buy it back. Burnett inspected the gun, telling Norris it was in bad shape. Norris took it from Burnett, and it accidentally fired. Burnett's right hand lost four fingers. The second barrel discharged, removing Burnett's right kneecap. After having his leg amputated, he went into shock. He died two days later and was buried in section A1.

Arthur Eldert was 19 years old when he was killed by a train on March 5, 1906. He moved from Detroit to work in Sprague, Ontario. His father wired Arthur to let him know he would soon be visiting him. Arthur went to the train station, and in a freak accident, the train he was expecting his father to be on killed him.

Arthur's father was not on the train since he had not been able to make the trip and had not contacted Arthur to let him know the change in plans. Arthur was brought home to Detroit to be buried in the family plot in section B.

Oscar Lowman died on February 1, 1939, at the age of 78. Born in Cincinnati, he moved to Detroit and practiced medicine. A Harvard University graduate, he studied chemistry at Heidelberg University. With a partner named Lambert, he established a wholesale drug company. His wife, Katharine, died in 1928, and he remained a widower until his death. They are entombed in section South Lake.

Ken and Joyce Holmes discovered the marker of Ken's great-great-grandmother, Eleanor Holmes. A midwife living in Springwells, she delivered many babies in Greenfield, Springwells, Dearborn, and Detroit. On July 30, 1863, William Ford of Dearborn summoned Eleanor in the middle of the night and paid her $5 for delivering his son, Henry. Eleanor died on April 8, 1895, at the age of 65 and is buried in section A5.

Christopher Warmbier started a general merchandise store in Wyandotte and ran the business until two years prior to his death on May 10, 1931. He was born above his parents' store where Elm and Second Streets meet, and his store was at the corner of Orange and Third Streets. Spending his entire 75 years living in Wyandotte, he helped found Immanuel Lutheran Church. He is buried in section H.

It was the last Sunday in May 1874 when Anthony and Eva Wolf lost two of their daughters. Annie, 15, and Caroline, 9, joined friends for a canoe trip in Roulo Creek near Woodmere Cemetery. The canoe capsized and the girls drowned with two other children. Rescuers tried to revive them. Anthony and Eva were buried at Woodmere Cemetery in section E. The graves of their children are unknown.

Alfred Ferris died on March 29, 1918. His son, Leo, died less than a year later. Along with other family members, they are entombed in this vault. One night in March 1985, three men broke into the vault and stole a corpse. They left the skull on a nearby porch. The rest of the body was found on a parked car. The vault doors were removed, and the vault located in section C was permanently sealed.

A car struck Sarah Isabelle. The driver fled but turned himself in to the police the next day. Isabelle was a passenger in a car driven when she saw an acquaintance sitting in a parked car. The driver let her out so she could speak to the person. She was hit as she crossed the street and died that day, November 29, 1931. She is buried in section M.

Tragedy struck the Broome household when they lost two sons to the evils of World War II. Pvt. Louis Wilfred Broome, 22, was killed in action on February 13, 1944. A few months later, his younger brother, Pfc. Raymond Earl Broome, 20, was killed. Both of them died in Italy. Almost three years after the war ended, the bodies of the soldiers, who had been buried in temporary military cemeteries overseas, were returned to the United States. The brothers, who lived in River Rouge, were laid to rest on July 31, 1948, side by side in section West Lawn.

Families were notified when the ship was expected to arrive and when the bodies were taken to the regional distribution centers of the American Graves Registration Service. Relatives were allowed to choose whether they wanted the bodies interred in a national or private cemetery. They could also request that burial take place in an American military cemetery overseas. William and Cora May Broome, parents of Louis and Raymond Broome, are buried in the same section as their sons but in a different lot. Cora died on March 3, 1967, and William died on October 30, 1969. They are in two different rows in section West Lawn, one being in the row above the other, not side by side as their sons.

Adolph Bennert, a Russian immigrant, came to the United States in the 1880s. He found employment as a butcher until he established his own grocery store, Fancy Groceries, and a meat market both located on Michigan Avenue. His business and his home shared the same building, which was the case of many business owners. He was 71 years old when he died on June 6, 1937, and is buried in section Park View.

Ireland native Capt. John E. Winn was 53 years old when he died on July 28, 1895. He was a vessel man for 35 years, 14 of those years as captain. Two of the vessels he had captained were the *Westford* and the *Monitor*. He left sailing and entered the coal and wood business. He is buried in section A1.

Alexander Nelson, 80, passed away on January 15, 1939, after many business ventures. Born in Scotland, he came to Detroit, working for a cartage company. He became a conductor of a horse-drawn streetcar, bought a coal business, went into the hotel business, and ran a grocery store. He is buried in section A5.

Lake, Clark's Park, Detroit, Mich.

Little is it known that Nelson fought for free textbooks in the public schools. He is also known for being instrumental in helping to keep Clark Park in Detroit, seen in this old postcard, open for public use.

Minnie Thomas was 49 years old when she died from pneumonia in April 1928. She assisted her husband in his Wyandotte drugstore, where she was deeply missed by hundreds of customers who had grown accustomed to her constant cheerfulness. Pneumonia was one of many diseases that would snuff out lives within days of contracting it. She is buried in section Indian Hill.

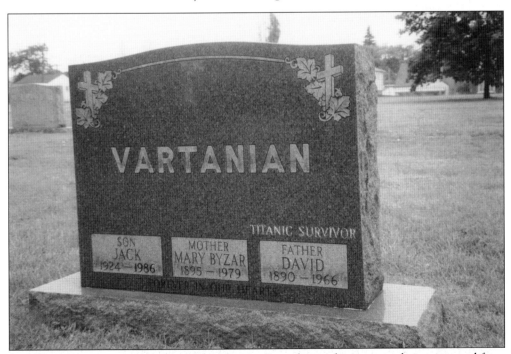

David Vartanian was a passenger of the *Titanic*. According to his account, he was rescued from the sinking ship, although it was debated whether he was rescued or if he saved himself by climbing aboard a lifeboat. He died on August 3, 1966, at the age of 76 and is buried in section West Ridge.

Henrietta Sylvester died in 1892 but never had a headstone. She was a 58-year-old widow when she gave up her home in Germany and came to America in 1872. In 2003, 111 years after her death, a great-granddaughter and a great-great-granddaughter honored her by purchasing a headstone for her grave located in section K.

Woodmere Cemetery

Name _Raymond Sylvester_

Date of Burial _May 3 1916_

No. of Grave _68_

No. of Block _41_

Section _E_

Undertaker _H C Baesinger_

Superintendent

Families were given cards with the name and grave location of the deceased on them. Most of the graves in this section are single graves and were used for those who could not afford a family plot. This little one, a grandson of Henrietta Sylvester, was almost two when he died from pneumonia during a bout with measles and was buried in section E.

Casper Speck, 50, a farmer and saloon keeper in Ecorse, died on May 14, 1894. His wife, Henrietta, when she died on March 6, 1918, was buried next to him. The inscription on his side of this unusual marker in section I reads, "No pain no grief no anxious fear, can reach the peaceful sleeper here." Henrietta's side reads, "A loving friend a mother dear, a tender parent lieth here."

"Lemmer-Maker" is engraved on the Specks' marker base. Henry Lemmer's Sons were grave monument manufacturers and had their business a block east of Woodmere. Henry started the business in 1874, becoming a master of his craft. His name also appears on the AOUW Detroit Lodge No. 6 monument constructed in 1891 and located in section A5. The business was passed down through the family, closing in 1968.

William Hill, 69 years old when he died on March 4, 1882, manufactured clothes wringers. Zinc markers, once thought of as being chintzy, have stood the test of time. These muted blue headstones have survived the elements better than many other types of markers. This one is located in section F.

On July 31, 1940, S. Sgt. Edward Lutman, was killed during gunnery practice. Loaded shells were erroneously substituted for blanks. The United Cemetery Workers union was on strike and was not allowed to postpone the strike to bury him. The VFW dug the grave and paid the union $7.50, the cost for digging a grave in section U.S. Army. Lutman was buried with full military honors on August 17, 1940.

Two days before Staff Sergeant Lutman died, 30-year-old Mabel Gores and her seven-year-old son, Donald, were killed in a car accident. Because the husband and father, Nicholas Gores, was a fellow unionist, the strikers allowed the funeral procession through the gates. It was non-striking employees who dug the graves in section East Lawn on August 2, 1940, but friends of the family had to fill in the graves themselves. The Gores' family was on their way to a family picnic. Nicholas and his other son, Bobby, a one-year old, were spared. The driver of the car that caused the accident was charged with negligent homicide.

Joseph Roulo, a 38-year-old painter and decorator with a wife and a small son, died due to a boating accident on September 14, 1910. He took some friends on his boat, the *Ida*. The boat was nearing a bridge that needed to be opened to make their passage through. Not having signaled for that to be done, Roulo was crushed between the boat and the bridge. He is buried in section M.

Jeanette Andrews was visiting her daughter in Marion, Ohio. On the morning of October 27, 1908, she was warming her hands near the fire. Her dress caught fire, and she was engulfed in flames. She was 80 years old and is buried in section B.

This photograph of section A5 was taken before the 1900s. Charles and Elizabeth Smith died from congestion of the lungs. Elizabeth was born on March 25, 1797, and died on July 27, 1869. She originally was buried at Elmwood Cemetery. Charles died on October 11, 1871, at the age of 78. He was a cabinetmaker in Detroit. (Courtesy of the Burton Historical Collection, Detroit Public Library.)

This is how the Smiths' grave site looks today. Section A5 is one of the oldest sections of the cemetery. No grave fencing was allowed, which included chains, posts, wood, stone, or any other kind that would take away from the rural look of the cemetery.

Eric Wolff, supervisor of the cemetery's grounds crew, stands near the headstone of his grandfather, Walter Wolff. Walter was a young boy when the cemetery's chapel was being built, and he helped with its construction. As the foundation was being poured, Walter's job was to poke the wet concrete with a rod to help air bubbles escape. He died on February 3, 1981, and is buried in section Park View.

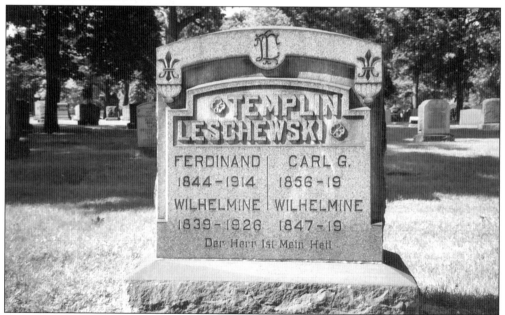

It was July 1936, and temperatures soared over 100 degrees. People did whatever they could to survive the ghastly heat wave. Some went to air-conditioned movie houses or Belle Isle to flee the hot air of the city. On July 14, the temperature dropped but only after claiming over 300 Detroiters. Wilhelmina Templin, 89, was one. Although not recorded on her headstone, in section Oak View, she died on July 11.

William Rowe was 89 years old when he was struck by a streetcar and died on June 25, 1919. Born in England, he came to Michigan and opened a shoe store in Corktown and ran the first night ferryboat, the *Rush*, between Detroit and Windsor. As a boy, he rang the bell at the Duffield Church to alert the neighborhood of fires. His mausoleum is located across from the Scripps vault in section A5.

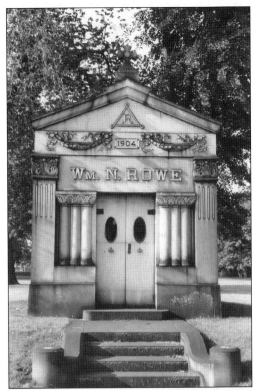

The cemetery grounds crew, Carlos Martinez, John Minor, James Sizemore, Michael Sherlock, and Mike Vail, uncover a marker that fell over and was buried for some time. It belongs to Louisa Rettke, who died on November 16, 1910. Within a week after stepping on a rusty nail, she developed blood poisoning followed by lockjaw. She suffered a very painful death at the age of 56 and is buried in section A5.

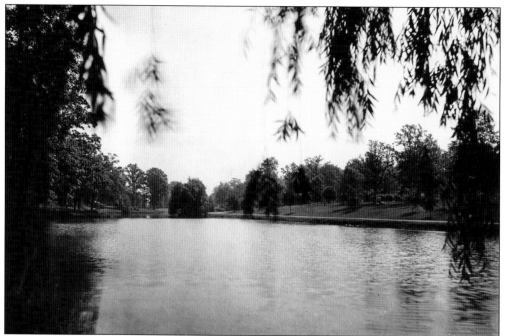

Looking toward section South Lake on the right, the serenity of Lake Woodmere, formerly Deer Creek, has been admired by thousands of people who have come to the cemetery to mourn the deaths of their loved ones and will continue for years to come to experience its therapeutic stillness. (Courtesy of Woodmere Cemetery.)

John Wilson, a 49-year-old tailor, was missing for several days, and it was noted in the *Evening News* on May 19, 1874. Forming a search party, his friends chartered a steamer to search the Detroit River, and on May 25, his body was found. By his friends' accounts he had been drinking, and he may have simply fallen in the water or decided to take his own life. He is buried in section D.

Four

RECORD KEEPING OF THE DECEASED

Since its beginning, Woodmere Cemetery has kept a three-by-five-inch card on file for each person. These cards give the name, last residence, date of death, date of burial, age, and burial section. If the person was buried in a family plot, the name of the deceased will appear on the family plot card in the order that the person died. The flip side of the card shows the layout of the plots, helping to identify the location of each person when visiting the cemetery grounds.

A daily logbook records who was buried each day. This book helps locate a person if a three-by-five-inch card cannot be found. Often in the older records, names may not be spelled as is thought. If the date of death is known, the logbook is a great way to find a person's information. The logbook also gives the cause of death, if known, and the name of the undertaker. Some of the very old records give the birth date and place of birth. Most records do not have information such as names of related family members. Ownership of graves is only available if a family plot was purchased. Through the course of cemetery ownership changing over the years, some of the earlier information may be missing or incomplete. Maps for each of the cemetery sections are available. Some of the maps for the older sections are being updated, showing surnames for each grave.

With the increased interest in genealogy, the cemetery's staff assists those researching their family histories. Mr. and Mrs. Ernest Bolla from Ohio along with their son, William, from Texas, came to Woodmere requesting information about their relatives. From left to right are Nellie Velazquez, counselor; Brian Morgan, counselor; Bill Shaw, sales manager; the Bollas; and Ray Dockham, counselor.

In Woodmere's records, many funeral homes are listed, but sadly, many of the buildings no longer exist, depriving researchers of another source of valuable information. This is the X. B. Konkel building built in 1922 that used to house the Konkel Funeral Home. It is located on Michigan Avenue not far from Woodmere Cemetery.

This home was once the Sutton Funeral Home. So many funeral homes from the late 1800s and early 1900s have been replaced by empty lots. Some of them have been converted for other uses including residences, churches, and retail businesses.

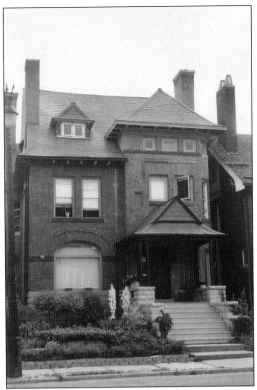

This was once W. R. Hamilton Funeral Home. Located on Cass Avenue, it was used by many of the more prominent Detroiters. Levi Griffin, Sigmund Rothschild, Dexter Ferry, the Carhartts, Claudius Candler, and Henry Leland were some of the many whose services this funeral home arranged. (Courtesy of the Burton Historical Collection, Detroit Public Library.)

ACROSS AMERICA, PEOPLE ARE DISCOVERING
SOMETHING WONDERFUL. *THEIR HERITAGE.*

Arcadia Publishing is the leading local history publisher in the United States. With more than 3,000 titles in print and hundreds of new titles released every year, Arcadia has extensive specialized experience chronicling the history of communities and celebrating America's hidden stories, bringing to life the people, places, and events from the past. To discover the history of other communities across the nation, please visit:

www.arcadiapublishing.com

Customized search tools allow you to find regional history books about the town where you grew up, the cities where your friends and family live, the town where your parents met, or even that retirement spot you've been dreaming about.